THE ILLUSTRATED
Flower

TEXT BY EMILY BLAIR CHEWNING
DESIGNED BY SEYMOUR CHWAST

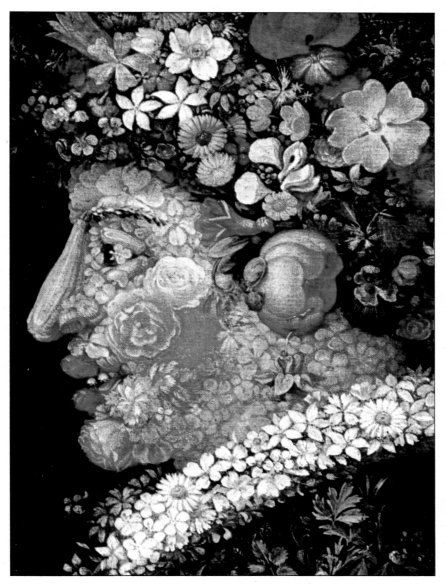

COMPILED BY J. C. SUARÈS
EDITED BY WILLIAM E. MALONEY
PICTURE RESEARCH
BY LAURIE·PLATT WINFREY

D1438562

A Push Pin Press / Omnibus Press Book
Omnibus Press

Dedicated to:
Sherwood Bryant
Hayward Cirker
Paula Scher

РРР A PUSH PIN PRESS BOOK PRODUCED FOR OMNIBUS PRESS IN THE U.K.

Push Pin Press
Producer: Jean-Claude Suarès
Editorial Director: William E. Maloney
Design Director: Seymour Chwast

First published in UK by
Omnibus Press
A division of Book Sales, Ltd.
78 Newman Street
London W1P 3LA England

Printed in Japan by
Dai Nippon Printing Co., Ltd., Tokyo.

We wish to acknowledge the assistance of
The New York Public Library for the mate-
rial on the following pages: 4, 7, 13, 14, 17,
20, 22, 26, 32, 36, 37, 56, 59, 66.

Any omission of credit is inadvertant and
will be corrected in future printings if
notification is sent to the publisher.

ISBN 0 86001 390 1

CONTENTS

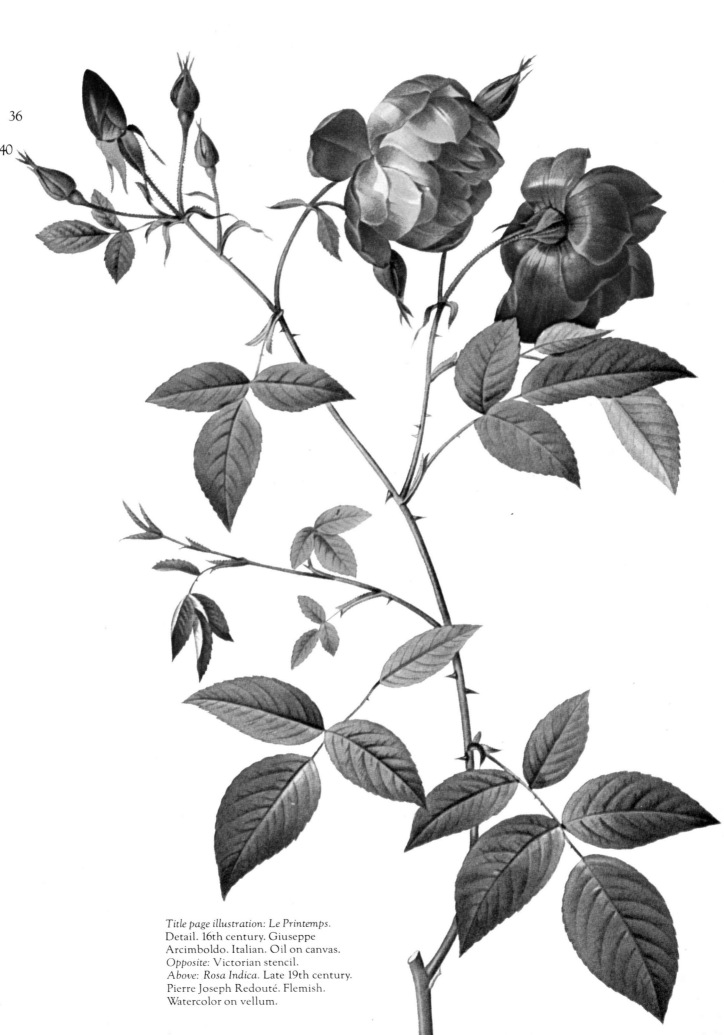

Title page illustration: Le Printemps.
Detail. 16th century. Giuseppe
Arcimboldo. Italian. Oil on canvas.
Opposite: Victorian stencil.
Above: Rosa Indica. Late 19th century.
Pierre Joseph Redouté. Flemish.
Watercolor on vellum.

hen flowers burst on the scene some thirty million years ago, they spread new colors and new forms across what had been a monotonous, gray marshland. But flowers provided more than beauty to the earth. They became the basic components of a food chain that allowed man to evolve from his primitive state.

The earliest plant systems began in the seas and were dependent upon water as a means of fertilization. Flowering plants, on the other hand, developed tiny encased seeds so light they were carried on currents of air and pollinated by the wind. The earth now supported a concentrated food source, adaptable and resourceful in reproducing itself.

Flowering plants provided the energy necessary for the complex metabolism out of which man's brain evolved. Loren Eiseley wrote of this eloquently in his book *The Immense Journey:* "The weight of a petal has changed the face of the world and made it ours."

As civilizations developed, wind pollinated flowers changed and improved, traveling far and wide, crossbreeding and evolving new types. From fossilized remains and old drawings we know that several of our modern flowers are remarkably similar to these early ones. Others are radically different.

Were it not for the illustrations that man through the ages has provided us, the story of plant evolution would be sketchy, and we would know little about the background of many of our favorite flowers of today.

Flower illustrations first appeared on the walls of caves. Fascinated by their colors and shapes (as well as their taste), primitive man drew crude pictures of flowers growing around him.

Early civilizations developed this rendering of flowers into art. The ancient Egyptians were captivated by flowers. Their temple walls were decorated with drawings of, among others, the lotus, the rose, the iris, and the lily. They also drafted detailed plans for elaborate gardens on these same walls.

The first plant-hunting expedition was organized by Egyptian Queen Hatshepset more than three thousand years ago. Illustrations of several plants brought back from what is now Ethiopia are in her temple at Luxor.

In the first century A.D., the Greek physician, Dioscorides, gave us the first illustrated book of flowers. His work *De Materia Medica,* was a collection of the many healing substances of plant origin that he encountered while traveling with the Roman legions through Gaul, Spain, North Africa, and Italy. Among the flowers he illustrated and described were roses, lilies, crocus, peonies, and iris. *De Materia Medica* was handed down over the centuries, copied and recopied and consulted for its information on the healing properties of plants.

During the Middle Ages, monks introduced flowers into their manuscript illuminations. Before this time, flowers were more valued for their practical character than for their beauty. The first

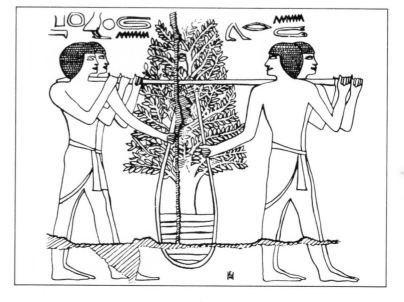

Opposite: Lady with a Pink. Detail. ca. 1668. Rembrandt Harmensz van Ryn. Dutch. Oil on canvas. *The Metropolitan Museum of Art.* Bequest of Benjamin Altman, 1913. *Right:* Rendering of Queen Hat shepset's Plant Collectors. 1495 B.C.

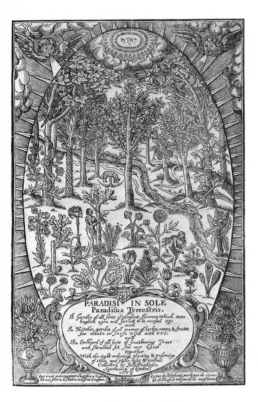

Above: Title page of *Paradisi in Sole Paradisus Terrestris* by John Parkinson, London 1656. The Garden of Eden in which all flowers should grow. *Courtesy of the Hunt Botanical Library. Below: Garden of Love,* a meeting place for lovers ca. 1450.

monastery gardens were primarily medicinal. The appearance of flowers in illuminations gradually shifted the emphasis from the practical toward the ornamental. In the sixteenth century, exquisite floral illuminations were created in Flanders and France.

The seventeenth century marked the formal beginning of flower painting. Flowers were now admired as subjects for paintings rather than as accessories and decoration in art. The painter was now allowed to express his delight in color, form, and texture. Flowers became a popular and enduring theme.

Holland and Flanders were the centers of flower painting during the seventeenth and eighteenth centuries. It has been suggested that the long, dark winter months in the Low Countries made the people so appreciate flowers that it was natural they should want to preserve their beauty and freshness in flower painting.

In the Orient, flowers were also chosen as the central theme in works of art. The Chinese and the Japanese celebrated nature in all its variable forms. The flower art from these countries is among the most admired in the world.

No story of floral painting would be complete without mentioning Pierre Joseph Redouté. A Fleming, descended from painters, he showed a remarkable skill in rendering flowers and a genuine love of them in his many volumes of work. Redouté is considered one of the great flower painters of all time.

Explorations into the most remote areas of the world during the eighteenth and nineteenth centuries increased the knowledge of flowers and brought forth a surge of botanical art. These intricate drawings were a method of recording and cataloguing the plant discoveries from these explorations.

In the nineteenth century, the French painters Monet, Manet, and Fantin-Latour dazzled the art world with their still-life impressions of flowers on canvas. It was also at this time that Van Gogh was inspired to do his series of flower paintings.

The Victorian era indulged its sentimentality in floral art. Some critics feel this sentimentality dealt the art of the flower a blow from which it has still not recovered. But others revel in the frilly, floral sentiments so dear to those years. It was during this period that the Language of Flowers became popular. This was the tradition wherein each flower was chosen to represent a sentiment.

Twentieth-century flower art has been more concerned with the flower in the garden or in its natural setting. So, in a sense, floral art has come full circle from its beginning, returning to a celebration of the flower in nature. But this century still has some time to go, and the story of the illustrated flower isn't over by any means.

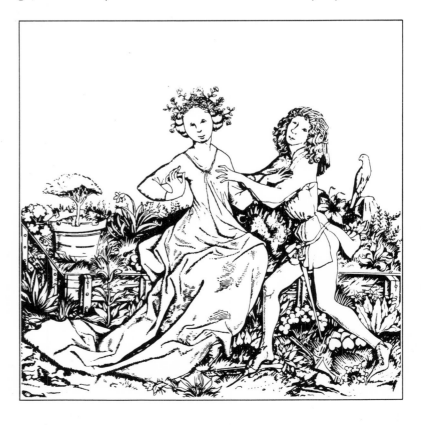

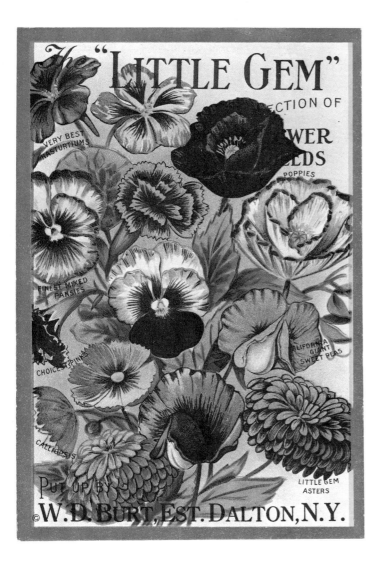

Below: A Vase of Flowers in a Niche.
Late 17th century. Jean Baptiste
Monnoyer. French. Oil on canvas.
The Metropolitan Museum of Art, Gift
of J. Pierpont Morgan, 1906. Left:
Seed packet from the early 1900s.
W. D. Burt, Dalton, New York.

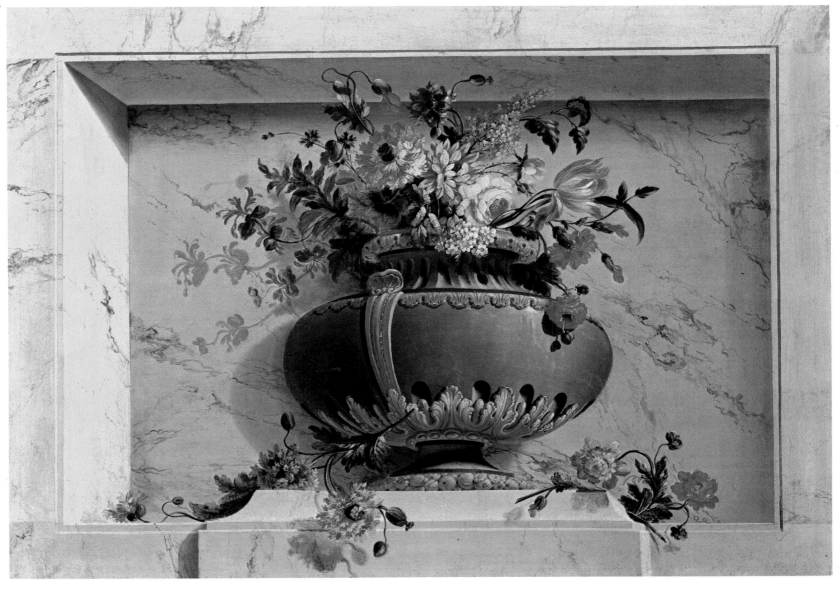

The Illustrations

The art of twenty-seven flowers, their history, legend
and meaning in the traditional Language of
Flowers as collected through the ages all over the world

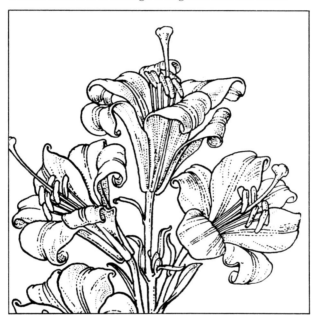

Anemone

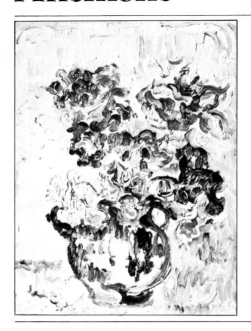

Anemone means "windflower" or "daughter of the wind." Pliny, the Roman naturalist, theorized that the flower would not open unless caressed by the wind. The anemone grows in almost every part of the world. Red, white, sky-blue, purple, pink, and mauve, the flowers spread a carpet of color wherever they choose to take root.

The lilies referred to in the Bible by Matthew (6:28–29) are believed by scholars to be anemones. "Consider the lilies of the field, how they grow; they toil not, neither do they spin: And yet I say unto you, that even Solomon in all his glory was not arrayed like one of these." There are no lilies that fit his description, whereas the anemone grew wild all over the hills of Palestine and the Levant.

The anemone was probably brought to Europe from the Holy Land by wandering pilgrims. They took along the roots of this little flower as gifts for those kind people who refreshed them along their journey.

During the Crusades, the anemone became known as the "blood drops of Christ." The story of how this came about is curious. Bishop Umberto of Pisa—after blessing some soldiers about to board a ship that would take them to war—instructed the ship's captain to bring back soil from the Holy Land instead of the usual sand as ship's ballast. This soil was scattered over the dead when they were buried at Campo Sancto in Pisa. The following spring, to everyone's astonishment, the Campo was blanketed with scarlet anemones. These "miraculous" anemones were given the name "blood drops of Christ." It was under this name that Europeans first came to know the flower.

IN THE LANGUAGE OF FLOWERS:
Expectation.

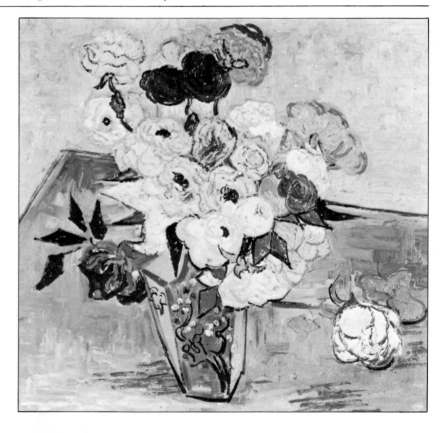

Opposite: Bouquet of Flowers. Detail. ca. 1905. Odilon Redon. French. Pastel on paper. *The Metropolitan Museum of Art.* Gift of Mrs. George B. Post, 1956. *Above: Anemones.* 1910. P. Signac. French. Oil on canvas. Paris, Collection Particular. *Right: Roses and Anemones.* 1890. Vincent van Gogh. Dutch. Oil on canvas. *Louvre,* Paris.

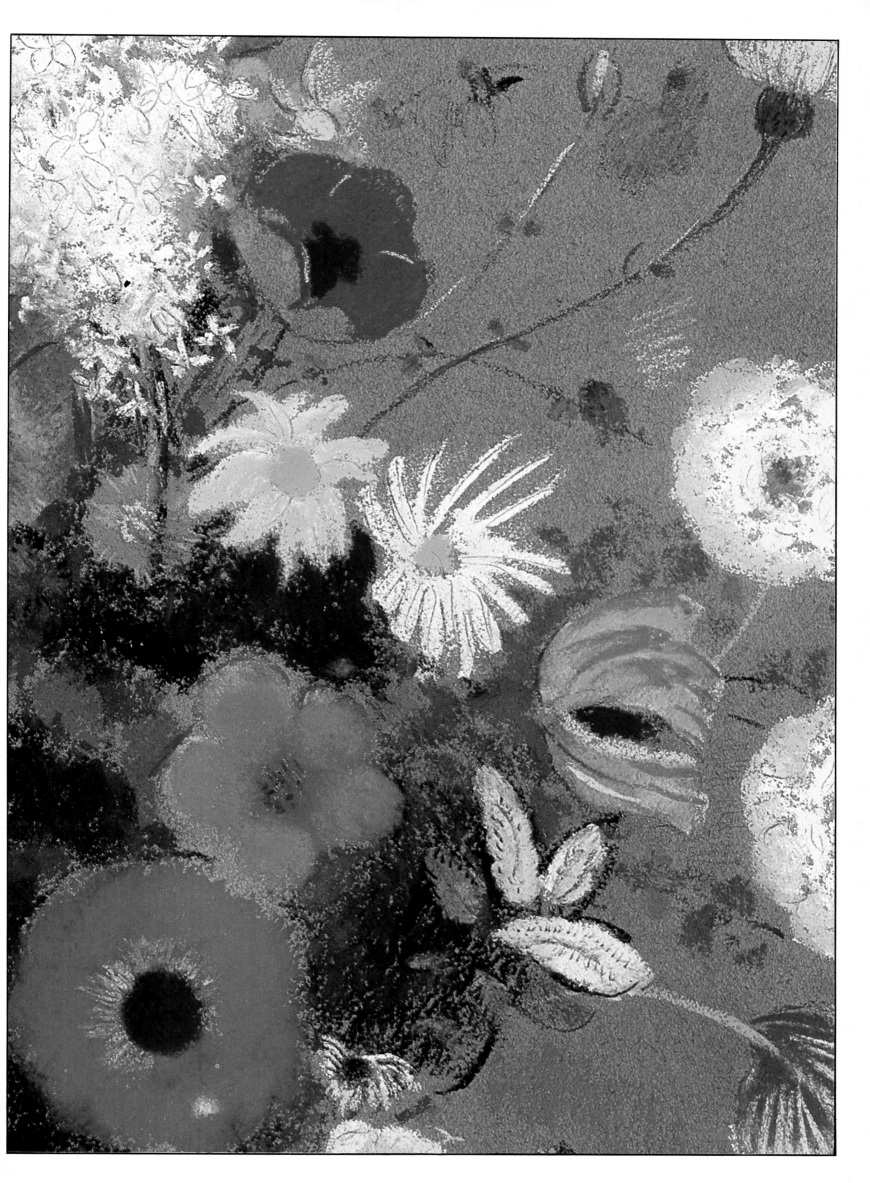

Aster

*"Never was there so
rascally a genus"*
—Asa Grey, American botanist

The aster was thought to be the flower the Roman poet Virgil mentioned in his fourth Georgic: "The altars of the gods are often adorned with the wreaths of these flowers. ...Boil the roots of this herb in the best-flavoured wine, and place baskets full of them before the door of the hive." Virgil was describing how to brew a tonic for the bees!

The aster was native to Italy, and was recorded growing in England around 1596. The English were fond of the flower. But they noted that it grew so fast and was so abundant in the garden that it would overtake the other flowers if not thinned constantly.

There were asters growing wild in many parts of America when the first settlers landed. On return voyages to England, different varieties were carried back and crossed with strains already under cultivation there. The aster plant that we know today is the descendant of these unions.

An alternate name for the garden aster is Michaelmas daisy. In 1752, Pope Gregory revised the calendar so that Michaelmas Day, September 29th, fell eleven days earlier, thereby evening out the year. This date coincided with the time when a new species of aster had flowered. (Up to this time, the flower was known by the two names, aster and starwort.)

In the Middle Ages, an ointment made from asters was considered useful in treating wounds, especially dog bites.

All three hundred species of the aster have flowers with purple rays. Asters grow wild and are cultivated in gardens all over the world. They need little or no attention, and will flourish in almost any quality of soil. They do like full sun and plenty of water.

IN THE LANGUAGE OF FLOWERS:
Daintiness.

Opposite: Aster Bigelori. Mid-19th century. Artist unknown. English. Botanical lithograph. Above: Engraving from 1888 Farm Annual. W. A. Burpee & Co., Philadelphia, Pa. Right: Seed package from W. D. Burt, Dalton, New York 1900s.

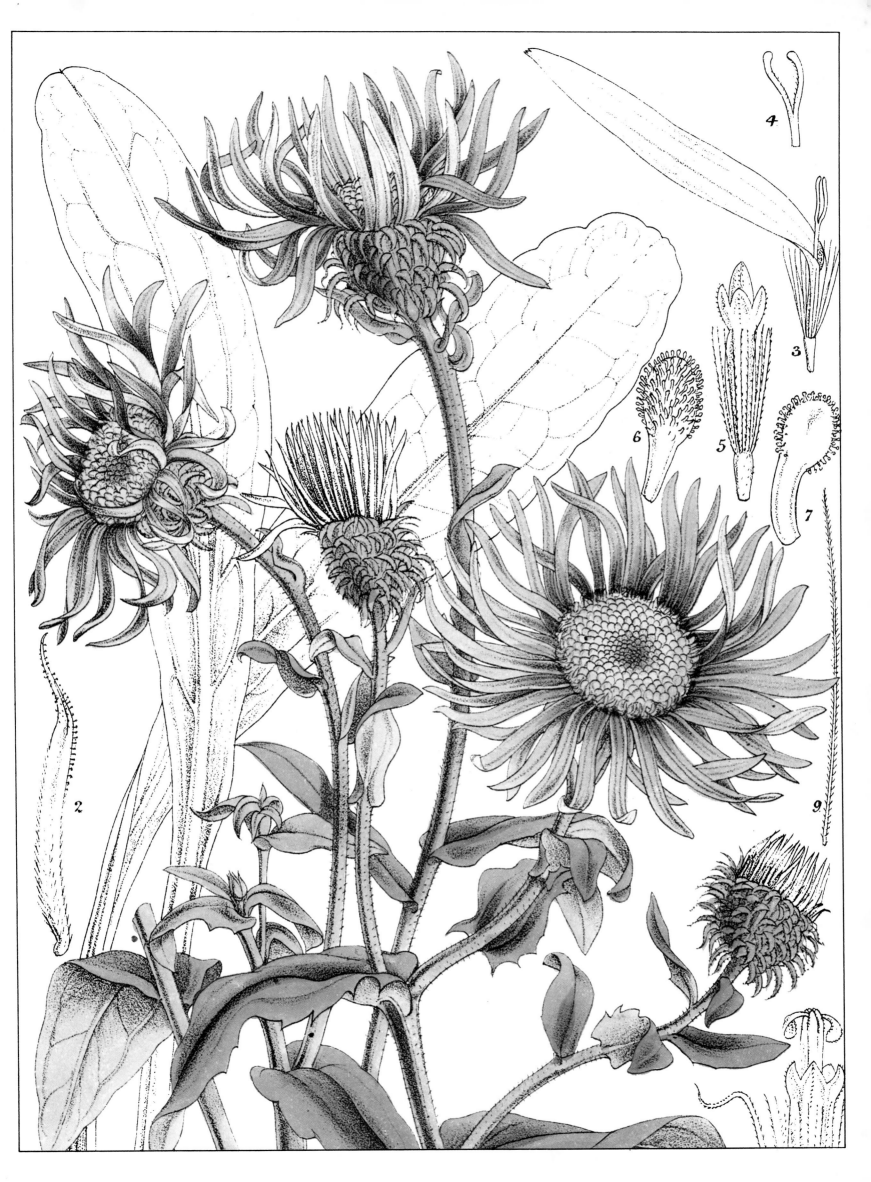

Camellia

There is a curious legend about the camellia and why early in history it was dubbed the tea plant. Around A.D. 510, an Indian prince named Bodhidharma was believed to have landed on China's southern coast with the purpose of converting the Chinese to Buddhism, his adopted faith. Such was his fervor that he dedicated his life to praying and meditating and teaching without even pausing to sleep. One night, however, Ta-Mo, as he was called by the Chinese, fell asleep despite all his efforts. When he awoke, he was so horrified at his weakness that he cut off his eyelids and flung them to the ground. According to the legend, Buddha transformed the eyelids into the beautiful flowering camellia plant. The leaves, when dried for tea, resemble eyelids and are believed to induce wakefulness.

Another legend concerns a Buddhist monk who was responsible for discovering that camellia leaves could be made into a tea. He was stoking his fire with branches of the shrub when some camellia leaves accidentally fell into a pot of water that was boiling. Later when he drank the water, he was enchanted with the taste of the beverage. Pleased with his discovery, he traveled the country informing others about this new drink. Eventually, the brewing of this tea spread throughout China.

By 1606, the Dutch had started tea plantations in Java. They brought camellia plants back to Europe.

One of the camellia plants was cultivated for its seeds, which produce an oil useful for processing textiles in the silk industry. This oil was also used in soaps.

The camellia was named after George Kamel (Latinized as Camellus) (1661–1706). He was a Jesuit priest who had a keen interest in natural science. He collected many types of plants in the Philippines and China.

From its origins in the Far East, the camellia has spread across the globe. The blossoms of this shrub range in color from pure white to a deep blushing pink to a fiery red. The shrub thrives in cool shade and needs little or no pruning. Some varieties of the camellia bear striped flowers or flowers with irregular blotches of color.

IN THE LANGUAGE OF FLOWERS:
Excellence, the white camellia;
Perfected loveliness, the red camellia.

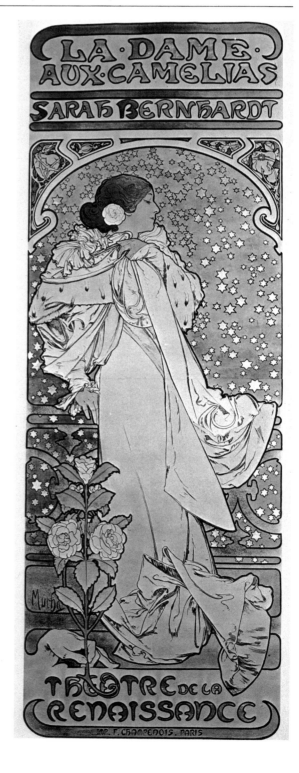

Opposite: Camellia Comte Maffeis.
Late 19th century. Bernard-Léon.
French. Botanical lithograph.
Above: Alphonse Mucha's poster
for *La Dame Aux Camellias* with
Sarah Bernhardt. Paris 1896.

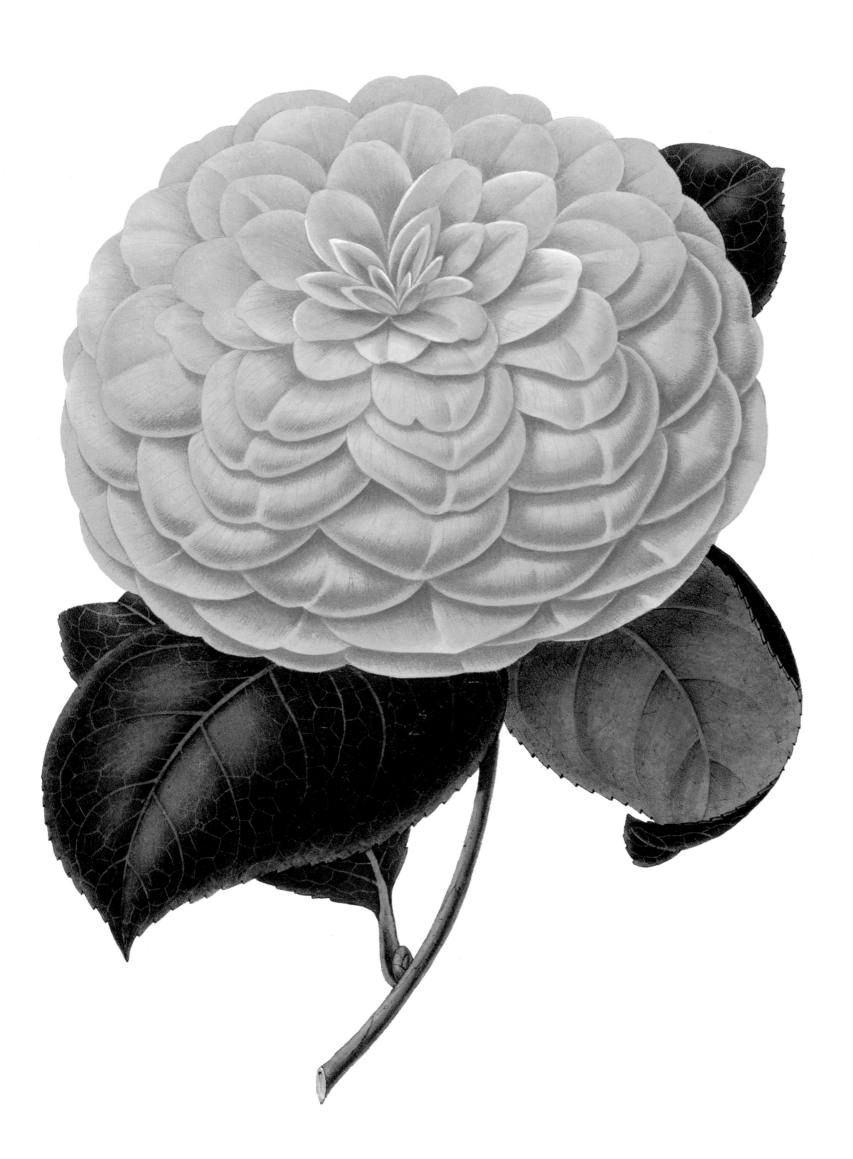

Carnation

The carnation deserves the name originally given it by the Greeks, Dianthus, divine flower. Theophrastus in the third century B.C. gave this name to the ancestor of the carnation, the little clove pink. Centuries of breeding and cultivating the flower have developed its beauty and fragrance, resulting in the carnation that we know today.

The carnation has a wondrously sweet scent and an incredible range of colors: striped or plain, red, pink, white, yellow, blue and mauve. Its nectar, concealed deep within the heart of the flower, is a favorite secret cache of the butterfly.

Pliny, the Roman naturalist, says that the clove pink was discovered in Spain in the days of Augustus Caesar. We know, however, that the flowers were long grown by the Romans and Greeks who used them to make garlands and floral crowns. Carnation comes from the Latin word *carnatio* which means flesh. This association was probably due to the color of the flowers.

It is believed that the flower may also have been cultivated by the Moslems in Africa, and it came to England in some stone that was imported for building purposes after the Norman Conquest. It was noted as late as 1874 that there were still "wild" carnations growing all over a castle built by William the Conqueror.

The Carnation has also been known as the gillyflower. Chaucer and Shakespeare both refer to the carnation in various places as the "gilofre" or "gillyvore." Alice Coats in *Flowers and Their Histories* traces the derivation for gillyflower to the Arabic *quaranful*, a clove, (a scent the flower mimics). She follows this back through the Greek *karyophillon*, the Latin *caryphyllus*, Italian *garofolo*, and the French *giroflée*.

In the Middle Ages, the petals of the carnation were soaked in wine and ale to distill the flavor of the clove. A mixture of water and gillyflowers was said to be a good tonic for the heart.

In the nineteenth century, the carnation was so popular in England that competitions were held for which the flower had to be "dressed." The art of "dressing" consisted of removing all the bruised and discolored petals, then arranging by hand each separate petal to create the "perfect" flower. Kit Nun, a barber from Enfield, took his rightful place in history for perfecting the art of "dressing." His fame became widespread when he turned from dressing women's wigs to dressing carnations.

The Englishman William Cobbett said of the carnation, "For my part, as a thing to keep and not to sell; as a thing, the *possession* of which is to give me pleasure, I hesitate not a moment to prefer the plant of a fine carnation, to a gold watch set with diamonds."

IN THE LANGUAGE OF FLOWERS:
Capriciousness;
Alas for my poor heart,
 the red carnation;
Disdain, the yellow carnation.

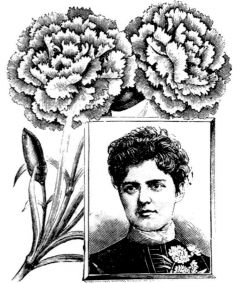

NEW CARNATION—MRS. CLEVELAND.

Opposite: A Group of Carnations.
1803. R. J. Thornton. British.
Watercolor for an engraving.
Above: Steel engraving of a
new carnation named for Mrs.
Grover Cleveland in the 1890s.
Below: Woodcut by Walter Crane
for *The Studio.* 1893. *Collection,
Dover Publications.*

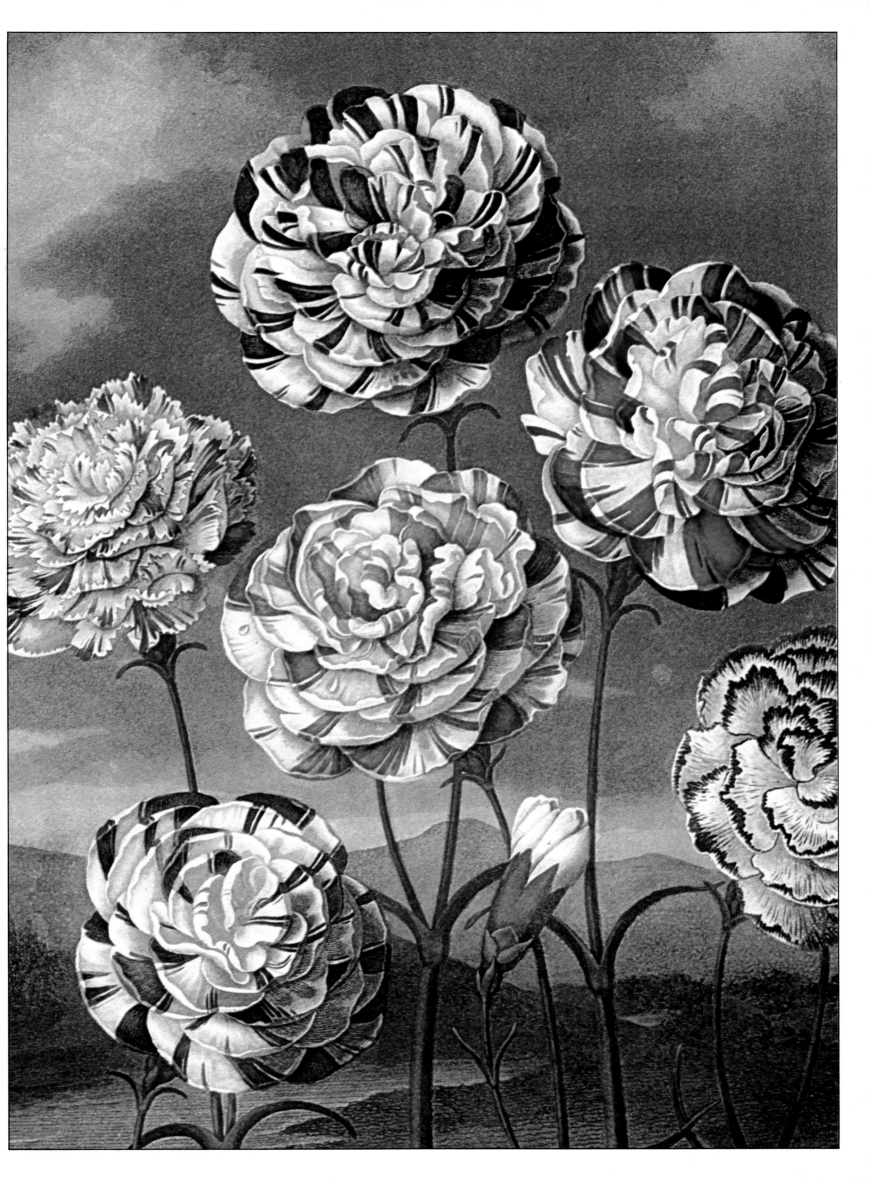

Chrysanthemum

Often referred to as "the queen of the autumn garden," the cheerful chrysanthemum has brightened many a crisp fall day. Chrysanthemum means "yellow flower," and it is thought that the first flowers of the chrysanthemum were predominantly yellow. Now, however, their colors range from deep red to rust, from rich yellow to orange, to white, and to mauve. Right up through the first heavy frost, the crowns of the chrysanthemum reign supreme.

A native of China, this flower has been as revered and beloved in the East as the rose has been in the West. The first written reference we have to the flower goes back to Confucius, who mentioned the chrysanthemum around 500 B.C. In the fifth century A.D., T'ao Yüan Ming cultivated the flower with such devotion that, after his death, the town in which he lived was renamed "City of Chrysanthemums."

Around the fourth century, China sent the first chrysanthemum to Japan. Despite the Japanese admiration for the cherry blossom, the chrysanthemum soon became popular. The Japanese called the flower "KiKu" and said that it symbolized the sun. The orderly unfolding of its petals represented perfection. The Japanese flag at one time was a chrysanthemum with sixteen petals around á central disc; it was not the rising sun as is frequently assumed

In A.D. 797, the mikado adopted the flower as his personal emblem. At that time, only the emperor and nobility were allowed to cultivate the chrysanthemum. The Order of the Chrysanthemum was the highest honor the emperor could bestow. There was no end to the poems and songs of praise dedicated to this flower. Even the emperor himself composed poems in honor of the sacred chrysanthemum.

Today, in the Orient, a particular chrysanthemum is cultivated for its petals, which are used in special dishes. And there is a richly flavored tea brewed from steeped petals in water.

It is thought that some Dutch traders brought the flower from China to Europe in the 1600s. Oddly, there was little interest in the flower at that time. It wasn't until the late 1700s that the chrysanthemum found a place in European gardens.

IN THE LANGUAGE OF FLOWERS:
Cheerfulness, optimism in adversity.

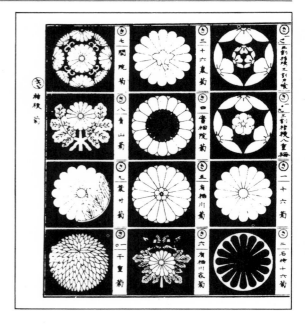

Opposite: Woman with Chrysanthemums. Detail. 1865. Edgar Degas. French. Oil on canvas. The Metropolitan Museum of Art. Bequest of Mrs. H. O. Havemeyer, 1929. The H. O. Havemeyer Collection. Above: Variations of ancient Japanese chrysanthemum designs for emblems conferred by the emperor on certain families. Some are over a thousand years old.

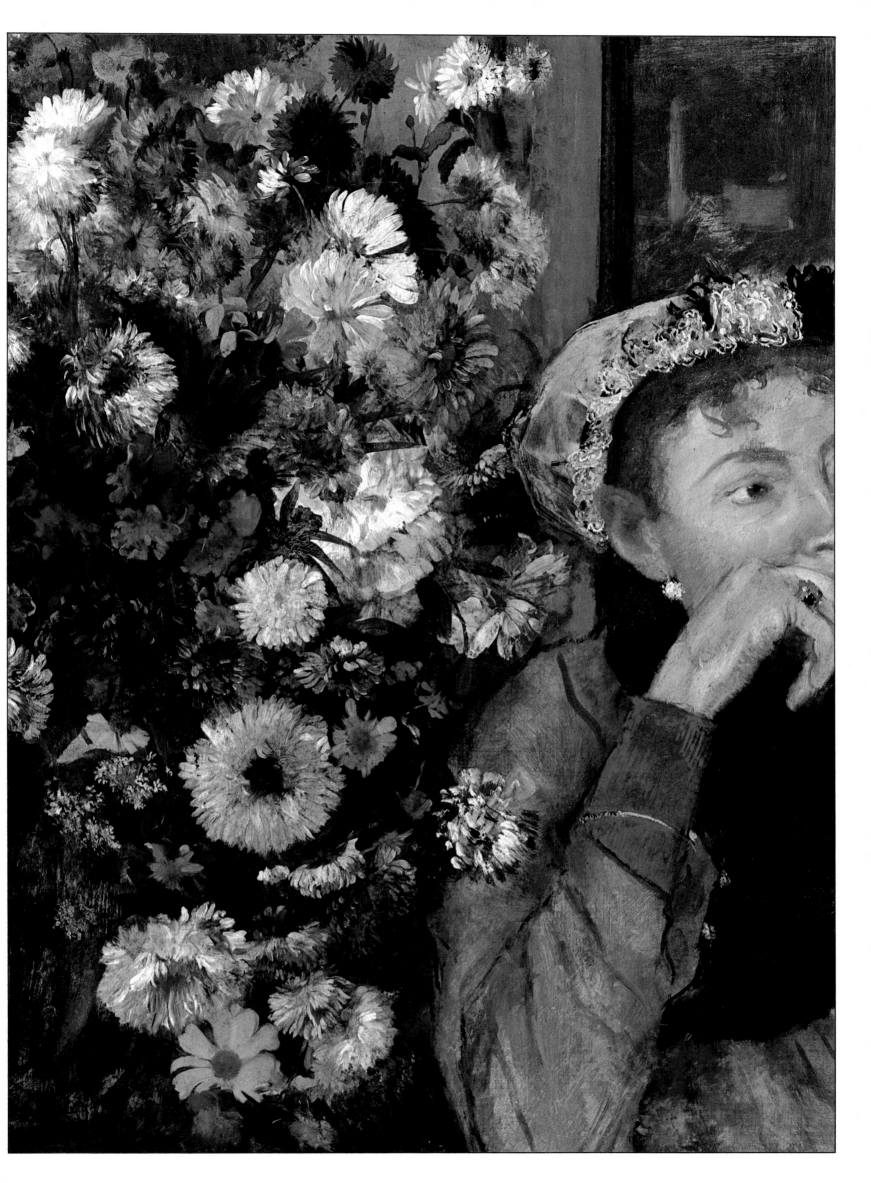

Crocus

The most famous member of the crocus family is *C. sativus*, the saffron crocus. Saffron, the seasoning that can be found on many kitchen shelves, has also been used in medicines and as a dye. Saffron is obtained from the dried stigmas of a pale lavender crocus. It takes an extraordinary forty-three hundred flowers to produce a single ounce of saffron.

While its exact origin is obscure, the saffron crocus has been known for centuries. Saffron-dyed robes in the Orient are mentioned in earliest recorded history. Saffron-yellow is the color of light and early became a sacred and royal color. Italian women of the Renaissance were known to have used the dye to color their hair after seeing the beautiful blond locks of their neighbors to the north.

During the reign of Henry VIII, a law had to be passed banning the use of saffron as a dye for linen sheets. The people had come to believe the dye was antiseptic and were neglecting to wash their saffron-dyed bed clothes.

The references to saffron as an ingredient in food and medicine go far back into history. The Song of Solomon refers to "Spikenard and saffron, calamus and cinnamon, With all trees of frankincense; Myrrh and aloes, with all the chief spices." (4:14) Saffron was also believed to lift the spirits, and be a good cure for an ailing stomach.

Richard Bancke's herbal, the first to be published in the English language, described saffron's uses this way: "The virtue of the herb is thus. It will destroy all manner of abominations of man's stomack, and will make a man to sleep. It is good for many medicines, and namely for cooks to colour their meat therewith."

Saffron is used today almost solely as a seasoning. The advent of synthetic dyes and modern medicine has made its commercial use obsolete. In the south of England where there were once acres of *C. sativus* under cultivation, one now sees only an occasional flower growing wild in the fields.

But if the saffron crocus has fallen from favor, the modern spring crocus is more popular than ever. In the language of flowers, the spring crocus means "youthful gladness." The sight of the first crocus that dares to poke its bright head through the late winter snow is a delight. Blue or mauve, yellow, white, striped or plain, the bloom of this little flower bears the promise that spring is on its way. These hardy little flowers will brave almost any kind of weather to flaunt their brilliant colors.

IN THE LANGUAGE OF FLOWERS:
Youthful gladness, the Spring crocus;
Mirth, the saffron crocus.

Opposite: Crocus and Snowdrops. 1802. R. J. Thornton. Watercolor for an engraving. *Right:* Botanical print of the saffron crocus, C. sativus. Late nineteenth or early twentieth century. English.

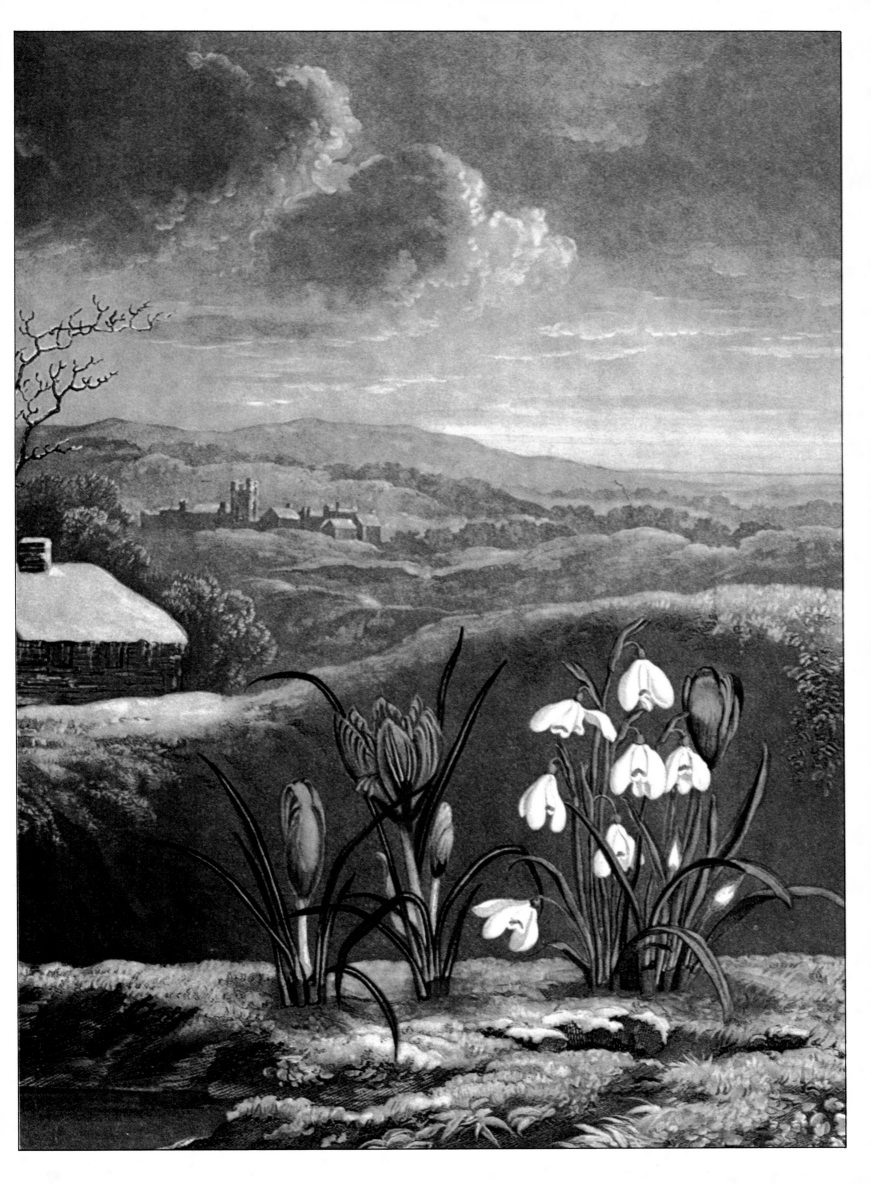

Dahlia

The dahlia, a native of Mexico, is a flower with enough varieties to confuse even the most devoted gardener. There are pompon dahlias, anemone-flower dahlias, semi-cactus dahlias, the single-petaled collerette, the large decorative dahlia, and the smaller variety called "twiggy," just to mention a few.

All dahlias come in rich shades ranging from a sun yellow to a fiery orange, a deep crimson to a coral pink, mauve, and purple.

The dahlia was named in honor of Dr. Andreas Dahl, a botanist and pupil of the world famous Swedish botanist, Linnaeus. In 1789, Vincent Cervantes, the head of the Botanical Garden in Mexico, brought seeds of the flower to Abbé Cavanilles of Madrid. The Abbé considered the plant more useful as a food crop than an ornamental flower. The Europeans, however, did not like the taste of the bitter roots. The dahlia of this period was hardly as impressive as the flamboyant dahlias of today. It was rather small and ordinary, and seemed destined to be forgotten.

It was Napoleon's wife Josephine who introduced the beauty of the dahlia to the world in her famous gardens at Malmaison. She found the dahlia exquisite, and cultivated many varieties of them. Dahlias were one of the flowers reserved solely for the royal gardens.

So beautiful were the dahlias at Malmaison that one of Josephine's ladies-in-waiting begged her lover to steal roots of the flower so she could grow them herself. The lover succeeded in bribing the gardener and received roots for one hundred flowers. But through palace gossip, Empress Josephine caught wind of the affair. She sacked her gardener and then banished her lady-in-waiting and her lover from the court. In a furious tantrum, Josephine also had her entire stock of dahlias destroyed. It was a great tragedy, for several varieties were lost forever because of Josephine's royal temper.

The dahlia has always been, for the most part, solely ornamental. But the Tunebo Indians of Columbia still eat the tubers, and North American Indians long used the roots for a bitter tonic. The petals of the flower can be eaten in salads like those of the chrysanthemum and marigold. But the leaves are tart and an acquired taste.

IN THE LANGUAGE OF FLOWERS: *Treachery.*

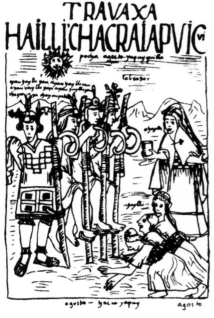
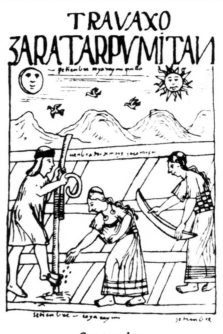
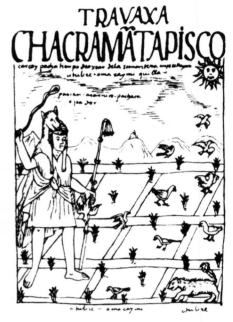

August

September

October

Opposite: Dahlia, Double Cactus Mixed. 1929. *Maule's Seed Book,* Wm. Henry Maule, Philadelphia, Pa. American. Engraving from the catalog. *Above:* An illustrated, late-sixteenth-century calendar in Spanish, depicting the Inca planting season. The Incas were thought to have cultivated the dahlia very early. *Right:* A Belgian chromolithograph by J. Guillot, late nineteenth century.

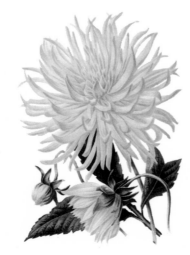

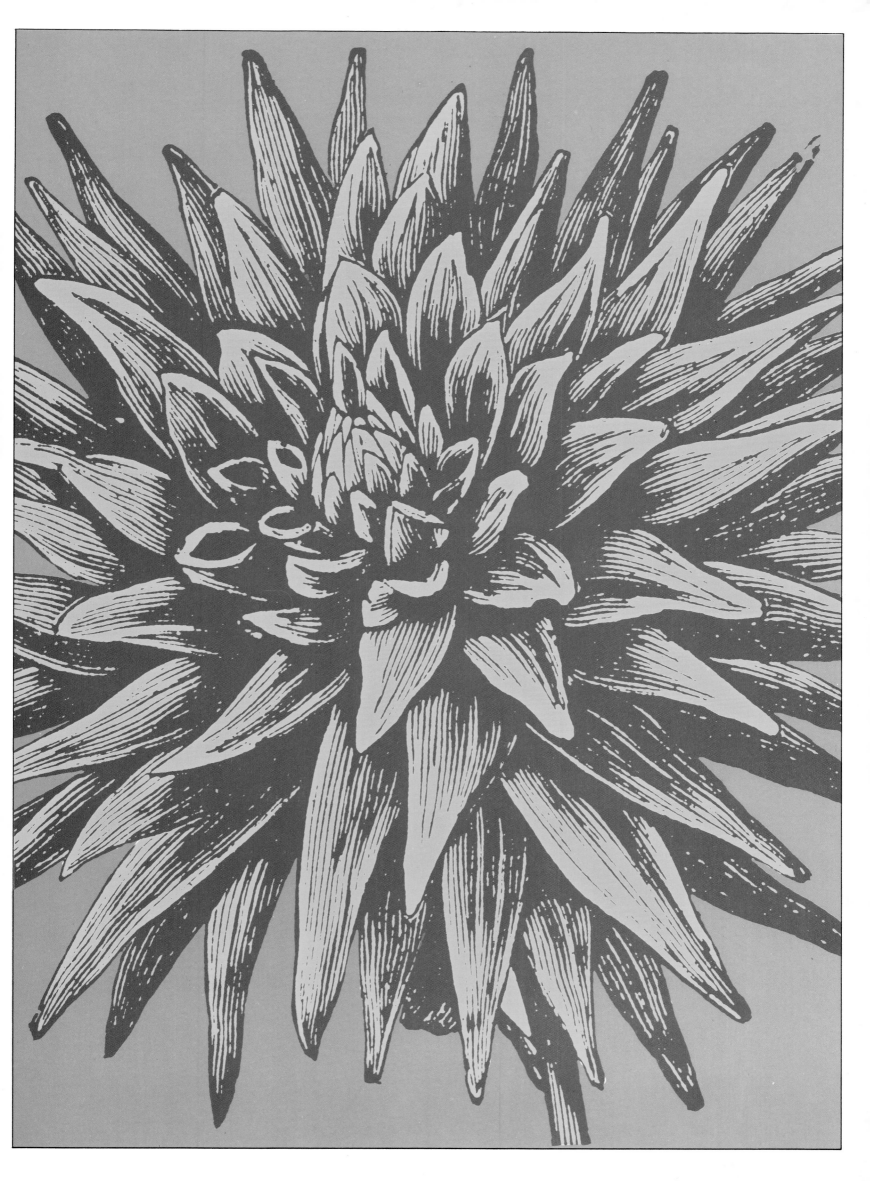

Daisy

The daisy is the flower of lovers and poets. To chance upon a patch of sun-drenched daisies, all nodding their white and yellow crowns in the breeze, is the most delightful way to discover their charm. The daisy has heard its praises sung in poetry and seen its honor inscribed on the armor of a queen.

Chaucer was one of the first to show his affection for the daisy. In his fourteenth-century prologue to *Legende of Goode Women,* he described how Queen Alceste was transformed into a daisy. The lady, he wrote, had as many virtues as the flower had petals. Burns, Keats, Wordsworth, Shelley, and other poets immortalized the daisy. Shelley called the daisy "those pearl'd Arcturi of the earth."

Not long before he died, the melancholy Keats wrote that he felt the daisies growing over him. The Latin name for the daisy is *bellis* and means war. This odd connotation occurred because the daisy was believed to have had the power to ease the wounds of dying soldiers on the battlefield. "To lie beneath the daisies" has become a metaphor of death.

Another name for the daisy is Marguerite. When Margaret D'Anjou married Henry VI in 1445, she took as her device three white daisies entwined on green turf. She had those daisies inscribed on her armor and embroidered on her garments and those of her attendants. It was probably at this time that the flower came to be called Marguerite. A few years later, another Margaret—Margaret of Beaufort—chose as her royal emblem a daisy growing through the center of a crown. One can still see this badge in the Henry VII chapel at Westminster Abbey.

The familiar refrain, "He loves me, he loves me not" was the theme for yet another name for the daisy, "measure of love." Lovers of old would pluck one, then another, petal from the daisy to the refrain. Though it is little known, most daisies have an odd number of petals. One need only begin with, "He loves me...," then all will end well.

IN THE LANGUAGE OF FLOWERS:
Innocence, the white daisy;
I share your sentiment, the garden daisy.

Opposite: The Hunt of the Unicorn III: The Unicorn Tries to Escape. Detail. Late 15th century. French or Flemish. Wool and silk with metal threads. From the Chateau of Verteuil. *The Cloisters Collection of the Metropolitan Museum of Art.* Gift of John D. Rockefeller, Jr., 1937.
Above: Advertising card from Milwaukee Harvester Co., 1891. Milwaukee, Wisconsin.

Dandelion

The golden crown of the dandelion belongs to the family of flowers called *Compositae.* This is a large group, consisting of some nine hundred genera and thirteen thousand species. *Compositae* includes among its members the chrysanthemum, dahlia, and sunflower. This is pretty good company for what some people regard as a common weed. But the dandelion was first a flower, and only later a weed.

The Bible considered the dandelion an important herb, mentioning it several times. It was also once considered an important medicinal flower. An extract from the flower was used for a tonic and a depurant. Doctors also recommended it for liver disease. In the 1700s, Dr. Zimmerman used it on Frederick, King of Prussia, as a cure for dropsy.

Today we use the dandelion for a delicious and tart salad green. We also drink a wine, and brew a tea, made from the flowers.

During the Victorian era, the dandelion was celebrated for its rural beauty. The Victorians felt that simplicity in plants, such as the dandelion, wild grape, thistle, white clover, sorrel, and mustard, exemplified a high moral truth that everyone should recognize and appreciate.

Dandelions were cultivated in the gardens of Colonial America. Along with the buttercup, dandelions escaped from the walls of the garden and spread out into the wild.

The dandelion got its curious name in France. Apparently some imaginative Frenchman thought its jagged leaf resembled the *dent de lion* or tooth of the lion.

IN THE LANGUAGE OF FLOWERS: *Coquetry.*

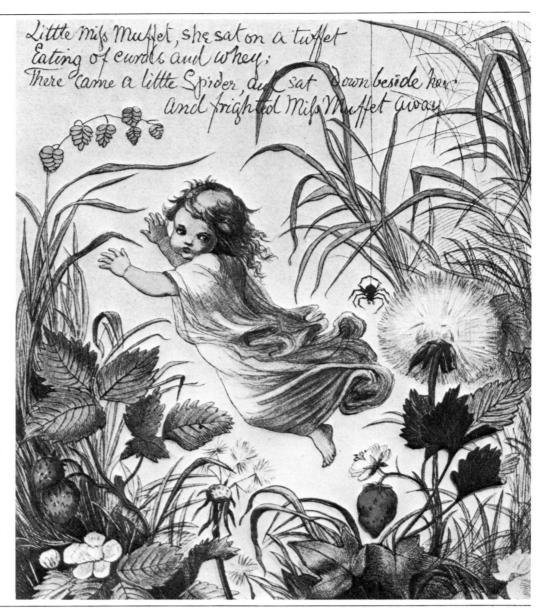

Little Miss Muffet, she sat on a tuffet
Eating of curds and whey;
There came a little Spider, and sat down beside her
and frighted Miss Muffet away

Opposite: Dancing Dandelions. 1948. Salvador Dali. Spanish. Oil on canvas. Collection of Carlos B. Alemany, New York. Above: Illustration from A New Child's Play, E. V. B. (Eleanor Doyle). Nineteenth century.

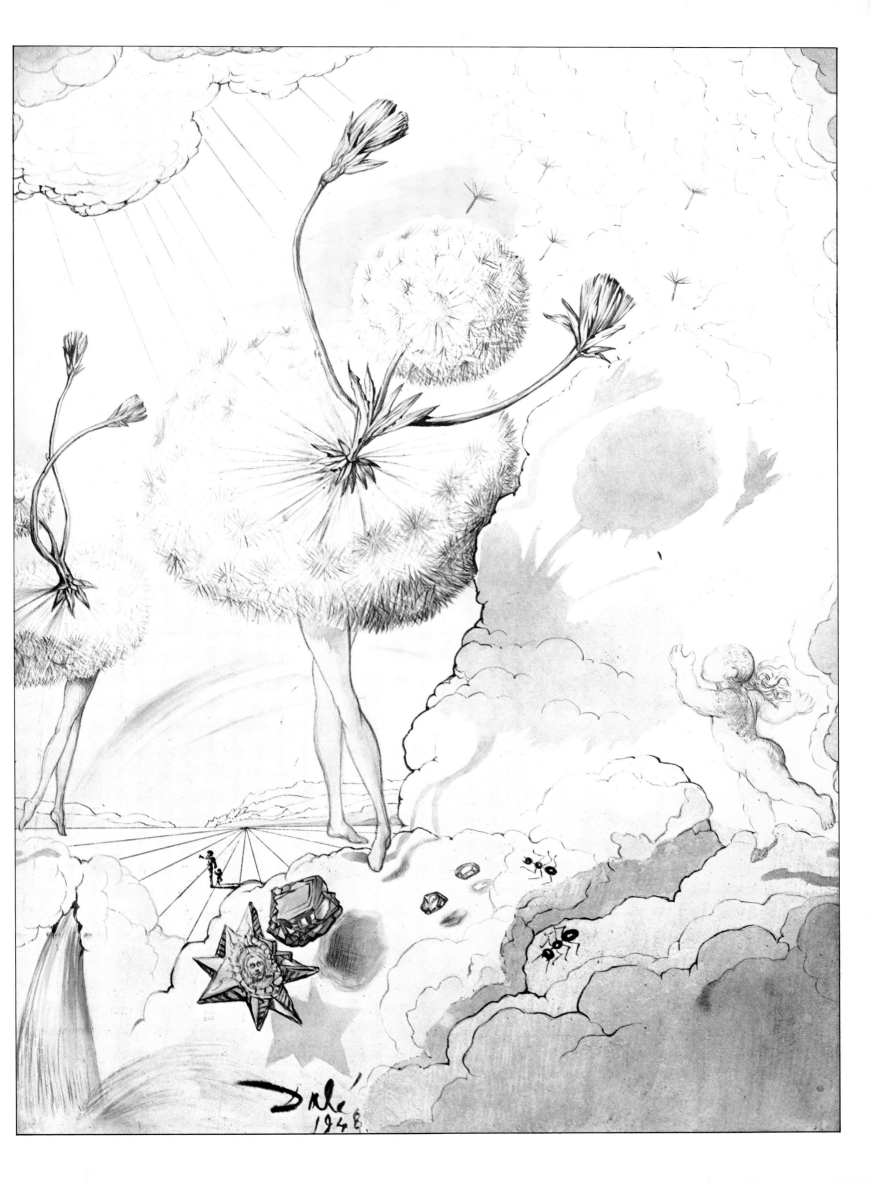

Geranium

There are few historical references to the geranium, but a legend does persist. It seems that one day the prophet Mohammed washed his shirt, then hung it on a mallow plant to dry. When he retrieved his shirt, the lowly mallow plant had turned into a lovely geranium.

During Queen Victoria's reign in England, the geranium was one of the most popular flowers. The rich planted them in great clumps in their gardens, while the poor put them in pots to brighten their window sills. The scarlet flowers when bunched into thick heads were compared to the brilliantly colored uniforms of the Queen's Guards.

Most geraniums are lightly scented, but when crushed they yield an important oil that is used in expensive perfumes and as a substitute for rose oil. It is one of the principal sources of the fragrance in rose soaps, cosmetics, shampoos, and toilet water.

Scented-leaf geraniums can yield an astonishing range of fragrances. Upon rubbing the leaves of these plants, one can identify fragrances such as those of roses, apples, peppermint, nutmeg, orange, lemon, eucalyptus, coconut, almond, apricot, lavender, and ginger.

The leaf of one type of geranium has been used in jellies and jams, and as a flavoring for milk pudding.

The geranium is a native of tropical regions. This brilliantly colored plant needs plenty of sun and a sandy soil. It has a good reputation as a houseplant. In a sunny window, it will bloom for months. Once in the garden, these flowers do well—unless there is too much rain. Seemingly lonesome for the sun, the geranium will not flower if the air is wet and the day cloudy and gray.

A nickname for the geranium is stork's bill, because the fruit bears a seed that extends out like the beak of a bird.

IN THE LANGUAGE OF FLOWERS:
Melancholy, the dark geranium;
Comforting, the scarlet geranium;
Steadfast piety, the wild geranium.

Opposite: The Terrace at Sainte-Andresse. Late 19th century. Claude Monet. French. Oil on canvas. The Metropolitan Museum of Art. Purchased with special contribution and purchase funds given or bequeathed by friends of the Museum, 1967. Above: Engraving from Abraham Munting's Decorative Floral Engravings, 1696. Dutch. Collection, Dover Publications.

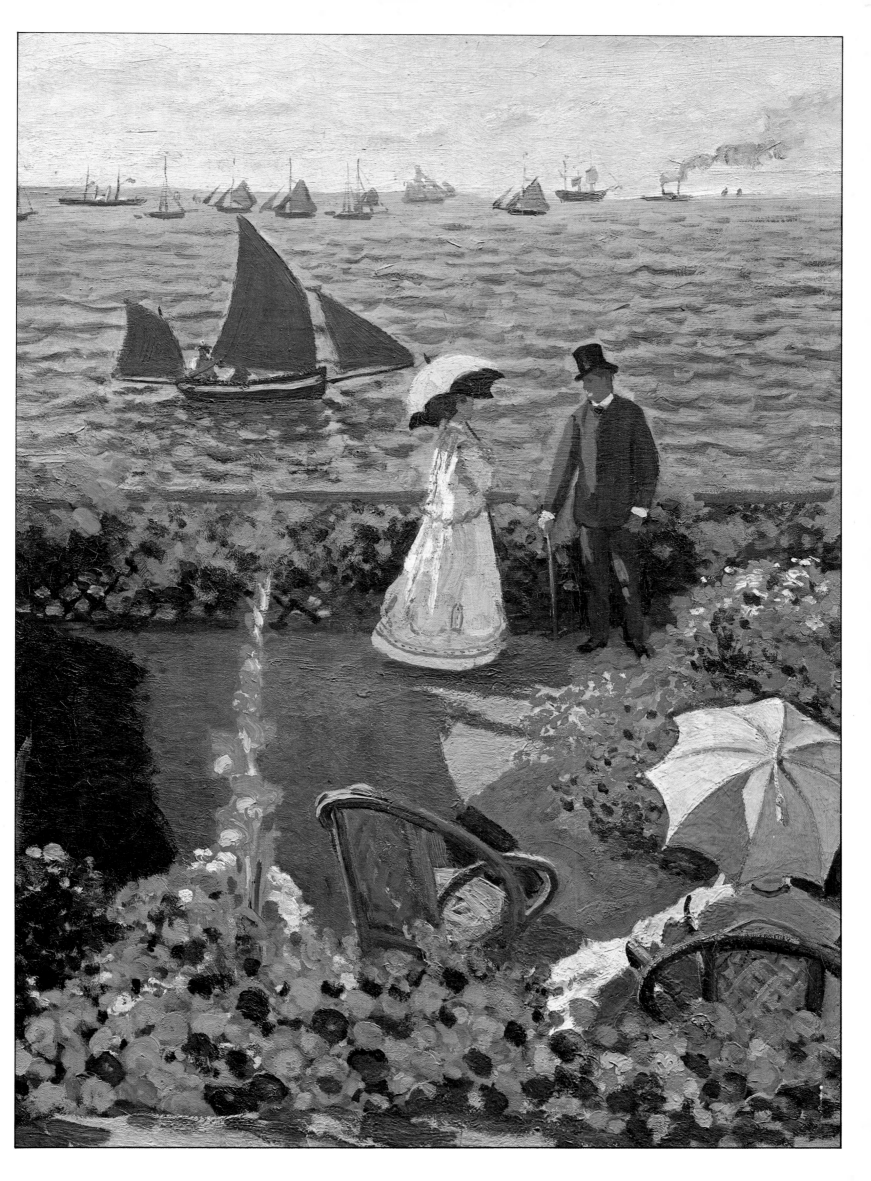

Iris

The stately iris is one of the oldest cultivated plants in history. The name of the flower is derived from the rainbow, because of its dazzling almost luminescent colors. In classical mythology, Iris was Juno's messenger, and the rainbow was her bridge between heaven and earth. The Roman historian Plutarch defined the word iris as "eye of heaven."

It is believed that the Egyptian ruler Thutmoses I brought the iris plant from Syria to Egypt almost fifteen centuries before Christ. There are many illustrations of the flower on the walls of the Botanical Chamber in his temple at Karnak. The Ancient Egyptians often used the iris to decorate the brow of their Sphinx. They considered the flower a symbol of eloquence.

During the medieval period, the iris was grown in monastery gardens because of the medicinal properties of its roots. It was thought that iris roots (rhizomes) would cure ulcers and induce sleep. Mashed together, the roots also served as a plaster for bruises. The roots were gathered and suspended in barrels of wine or beer to keep the beverages from spoiling.

The iris has been an important symbol in the history of France. It was the original model for the fleur-de-lys. According to legend, Clovis, who was king of France in the sixth century, found himself surrounded by a band of Goths near the Rhine River. Trapped, he looked across the river and saw some yellow iris growing way out into the water. Realizing that the water there was shallow enough to ford, Clovis was able to escape across the river. Soon after, Clovis adopted the iris as his device and it became the emblem of the royal family.

In 1147, when Louis VII joined the Crusades, he chose the iris as his symbol in memory of King Clovis. The flower became known as fleur-de-Louis, then fleur-de-luce, and finally fleur-de-lys (or -lis).

The fleur-de-lys is the symbol used to indicate North on compasses and maps all over the world. This came about in the Fourteenth century when the Neapolitan, John de Goiva, first used the magnet for navigation. He chose the fleur-de-lys as the universal symbol for North to honor France.

It wasn't until the eighteenth century that the famous Swedish botanist Linnaeus dropped the name fleur-de-lys in favor of the more classical iris.

Due possibly to its history as a royal emblem, the iris was often employed by Dutch and Italian old masters in their paintings of Christ to symbolize His divinity.

The iris served the Indians of the California desert regions in the nineteenth century. Indian squaws wrapped their babies in the soft green leaves of the Iris *Douglasiana* to retard perspiration, and thus dehydration, in the searing sun. The leaves have also been used by the Indians as fibre for cord, fishing nets, and snares.

IN THE LANGUAGE OF FLOWERS:
Eloquence, faith, promise.

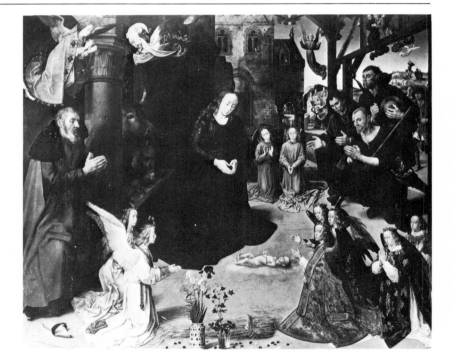

Opposite: Adoration des Bergers. Detail. Portinari Altarpiece. Mid-15th century. Hugo van der Goes. Flemish. Oil on wood. Florence Offices. Right: Adoration des Bergers. Portinari Altarpiece. Mid-15th century. Hugo van der Goes. Flemish. Oil on wood. Florence Offices.

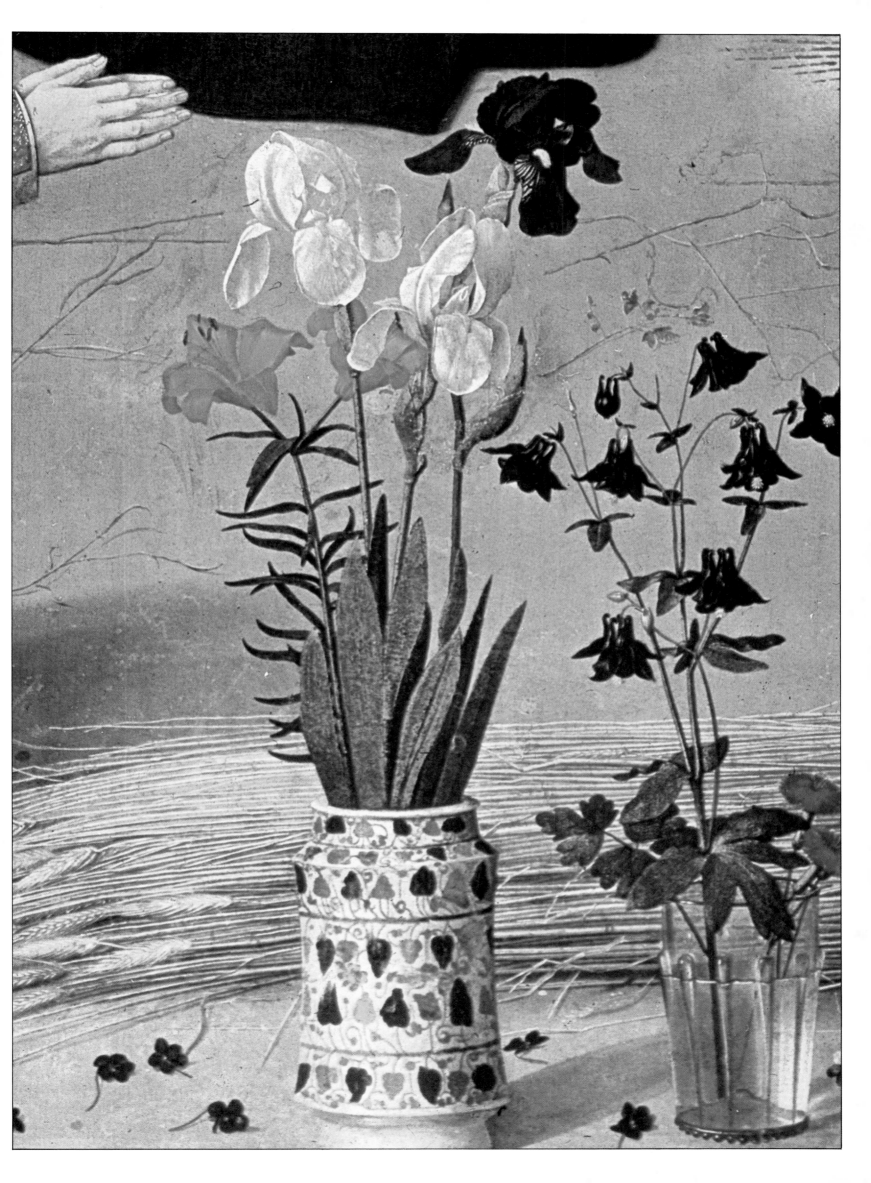

Iris

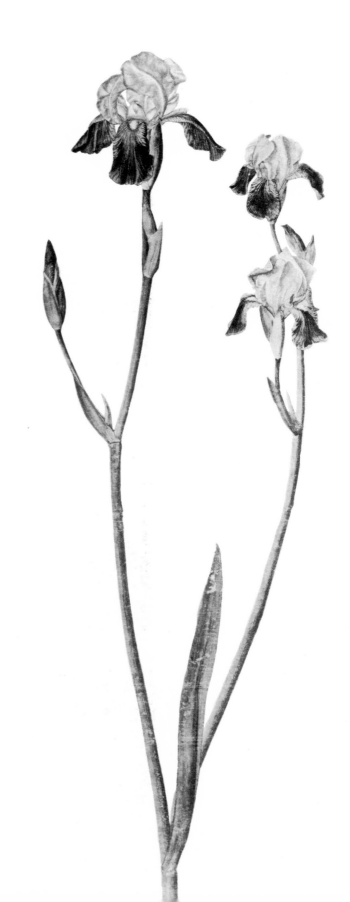

Opposite: Irises. Mid-19th century. Ando Hiroshige. Japanese. Print on silk. *Museum für Ostasiatische Kunst, Köln, Germany. Above:* Watercolor of *Iris germanica* by Albrecht Dürer, 1508.

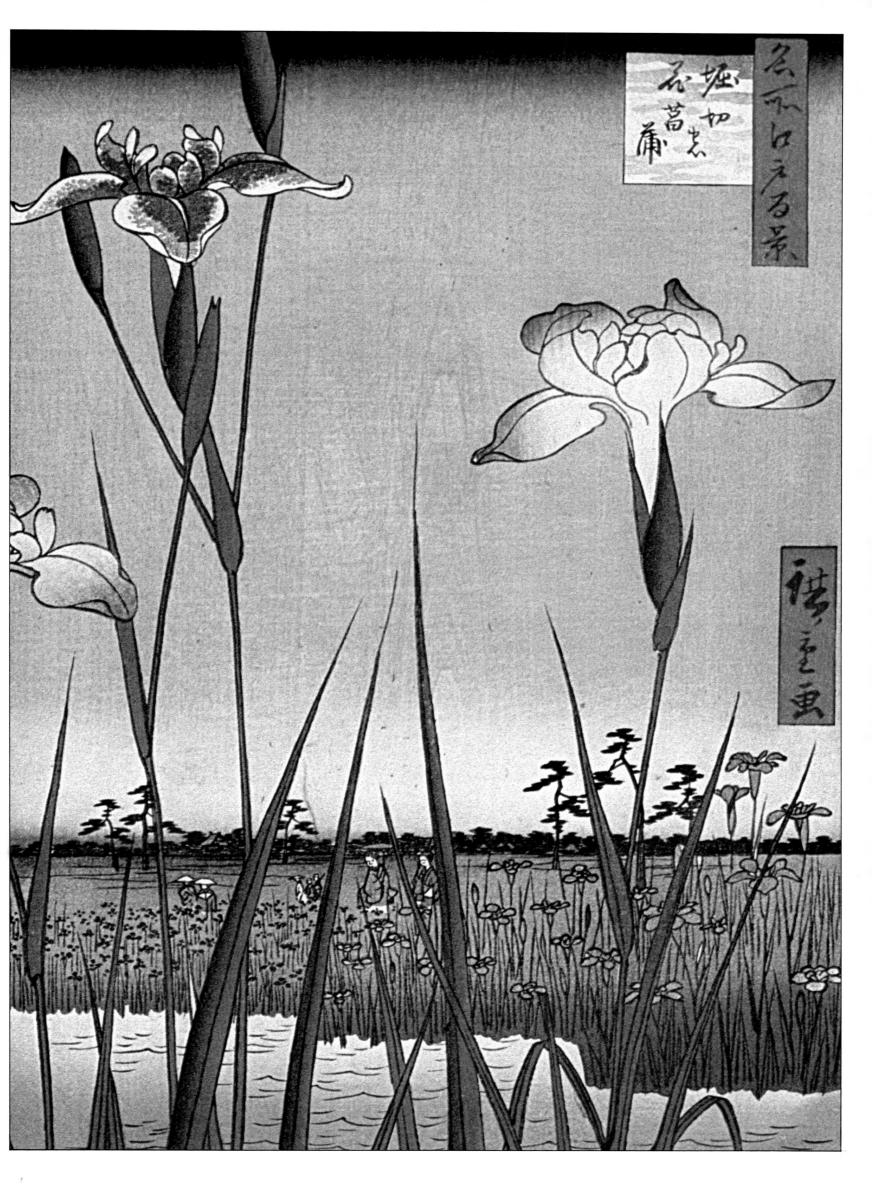

Lily

The story of the lily reaches deep into the past. Next to the rose, the classic lily, called the Madonna, is probably the oldest domesticated flower in history. Although no one is certain, its native habitat is thought to have been in southeastern Europe. Lilies can be found growing domesticated and wild in nearly every part of the world.

We know the Madonna lily existed as far back as 300 B.C. Renderings of the lily were found on Cretan vases and other objects from the middle Minoan period, 1750–1600 B.C. The flower was thought to have been the symbol of the Cretan snake goddess, signifying fertility.

The Greeks were known to have made wine from lilies and to have used oil of lilies in their cooking. There is one recipe that begins: "Take 1000 lilies…" and continues with the directions for making oil.

The Romans brought the Madonna lily to England and it was there that the flower became the emblem of the Virgin. The English historian-monk, the Venerable Bede (673–735) compared the white petals of the lily to the Virgin's immaculate body, and its golden anthers to her soul. The lily had an association with the Virgin dating from the second century. According to the story, lilies and roses were found in the Virgin's tomb three days after she was buried.

During the Middle Ages, lilies were cultivated by the monks for their medicinal properties. Lily leaves were used to treat burns and other wounds, especially the bites of serpents. An extract from the flower was said to be beneficial for the face, while the roots were used to treat boils.

There are many other varieties of lilies, among them the fiery tiger lily of the Orient and the reddish-purple martagon lily, probably from Syria or Greece. The tiger lily, besides being an ornamental flower, has been cultivated for centuries in China, Japan, and Korea for its edible bulbs. The martagon lily may have been one of the "lilies" mentioned in the Bible, although it is now believed these biblical references were to other flowers.

Whatever the differences of color and shape among lilies, the one attribute they all share is their heavenly fragrance. The enchanting scent of the lily glows with a sweet richness that is nearly unmatched in the world of flowers.

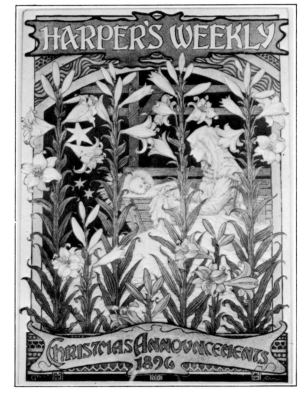

Opposite: Triptych. The Campin Altarpiece. Detail from *The Annunciation with Donors and St. Joseph.* Mid-15th century. Robert Campin. Flemish. Oil on wood. *The Cloisters Collection of the Metropolitan Museum of Art.* Purchase. *Above:* Poster for *Harper's Weekly,* Grasset, 1896. *Collection, Alan Trachtman. Below:* Masthead, *Vick's Magazine,* 1881.

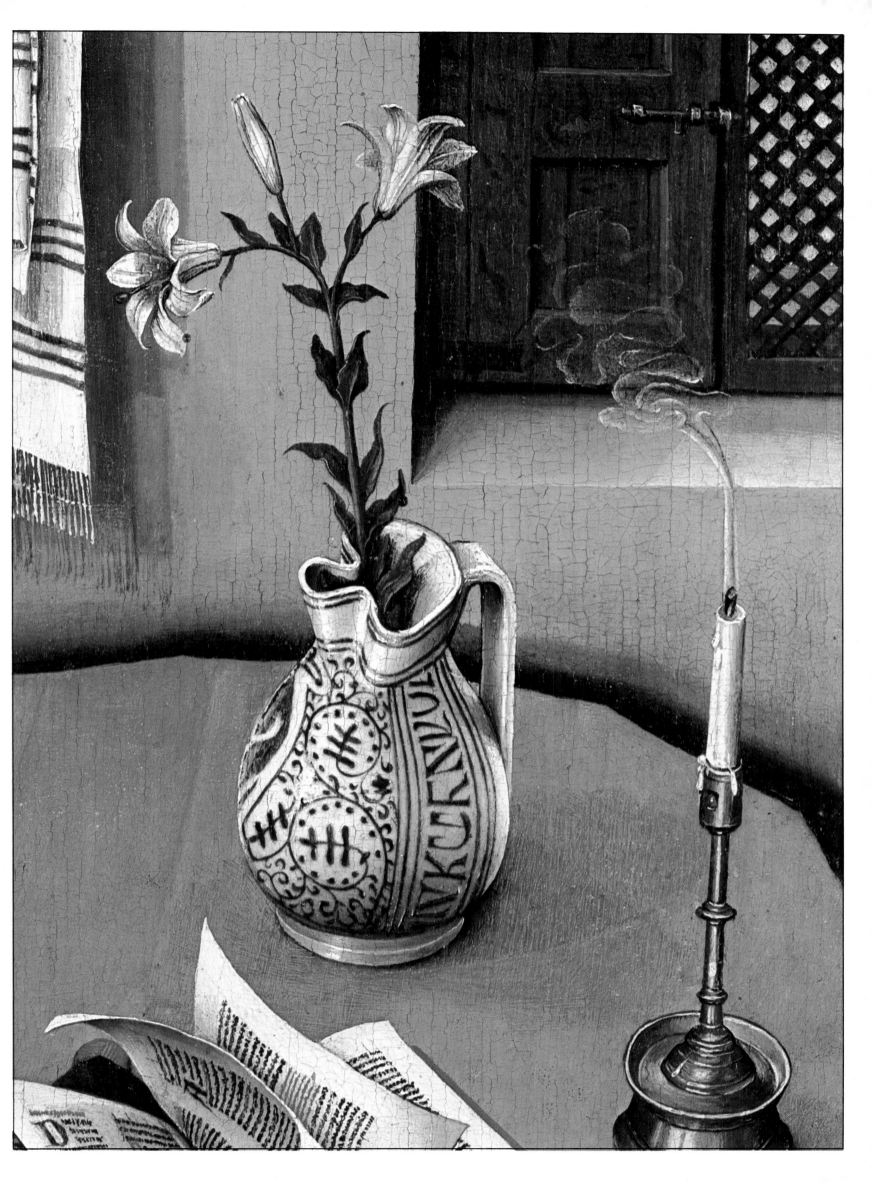

Lily of the Valley

The dainty white flowers of the lily of the valley bloom in late May. A native of Britain, this tiny, bell-shaped flower now grows almost everywhere in the cool woods and dales of northern climates. The flower has a fresh, sweet scent.

According to an English legend, the lily of the valley first bloomed in St. Leonard's forest. It was there that a certain Christian knight had fought and killed a dragon that had been ravaging the countryside. The lily of the valley was said to have sprung from the blood shed by this noble saint.

As early as the 1600s, the lily of the valley was among the flowers cultivated in English gardens. The little flowers were gathered and steeped in water for a month to make a so-lution called aqua aurea. This precious liquid was so highly valued that it was kept in gold and silver vessels. Robert Louis Stevenson, in the first chapter of *Kidnapped*, described a recipe for aqua aurea and recommended it: "It is good, ill or well, and whether man or woman. Likewise for sprains, rub it in; and for cholic, a great spoonful in the hour."

In the language of flowers, the lily of the valley means "the return of happiness." In medieval times, the flower was considered an important ingredient in love potions. There is still the belief today that a sprig of lily of the valley can help to mend a broken heart.

In the early 1800s, the lily of the valley was picked by the basketful for the English Whitsuntide festivities in May. There were dancing, drinking, and all sorts of joyful activities, the air heavily perfumed with the fragrance of the sweet white flowers.

In pagan times, the lily of the valley was the special flower of Ostara, the Norse goddess of the dawn. The lily of the valley is now the national flower of Finland.

The Latin name of the flower *Convallaria* came from convallis, "a valley." The lily of the valley has been given various names, one of the most charming being "Our Lady's Tears."

IN THE LANGUAGE OF FLOWERS:
Return of happiness.

Opposite: Lily of the Valley. 1889. Walter Crane. American. Watercolor for an illustration. *Above: La Guirlande de Julie-le-muguet.* Nicolas Robert. 17th century. Watercolor.

Marigold

"The Marigold observes the Sun
More than my subjects me have done..."
 Charles I, while a prisoner at
 Clarisbrooke Castle

The marigold's Latin name *Calendula* is derived from *Kalend*, also the root for our English word calendar. This name originated because the flower seemed to bloom every month, the whole year long. Our modern marigold does not resemble its somewhat drab ancestor, and is an example of how breeding can turn a rather plain wild flower into a beautiful, hardy garden plant.

The African marigold, in spite of its name, was originally a Mexican wild flower. The seeds of this plant were smuggled out of Mexico by Spanish traders. Somehow the seeds were inadvertently scattered along the coast of North Africa during one of their voyages. Called *Tagetes erecta*, the marigold grew so well in Africa that it became known all over the world as the African marigold.

This is the marigold once famous for emitting a disagreeable odor when its petals were rubbed or bruised. Through careful breeding and selection, this odor has disappeared in the newer strains of the plant.

The African marigold was eventually crossed with another variety, also of Mexican origin, the French marigold. The results were dazzling. The flowers were firmer, the stems more sturdy. Gardeners were able to achieve colors ranging from pale yellow to bronze, from fiery orange to tangerine, from maroon red to garnet brown.

Marigolds have been used for culinary purposes for centuries. The petals once served as a cheap substitute for saffron. Stirred into stews and broths, the marigold produces a rich cheesy flavor. The fresh petals of the flower are delicious in salads. There is also a recipe for marigold pudding that contains chopped petals, sugar, lemon juice, lemon peel, bread crumbs, and cream.

A curious trait of the marigold caught the attention of Elizabethans, as Shakespeare noted when he wrote: "The Marigold that goes to bed with the sun, And with him rises weeping..." The flower expands its petals in the morning, then shrinks them in the afternoon. Like the sunflower, the marigold also follows the sun across the sky.

The flower of the marigold was once believed to relieve the pain of a sting from a wasp or a bee. Both the color and the scent of the flower are believed to act as a repellent against harmful insects when the marigold is planted near the vegetable patch.

The marigold has sometimes been called the "death flower" in the United States. There was one story that described the marigold as having sprung from the blood of unfortunate Mexicans crazed from their lust for gold.

IN THE LANGUAGE OF FLOWERS:
Grief, despair.

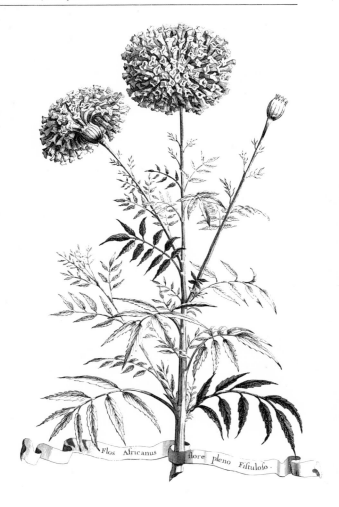

Flos Africanus flore pleno Fistuloso.

Opposite: Marigolds and Tangerines.
Detail. Late 19th century. Felix Vallotton. French. Oil on canvas. *National Gallery of Art, Washington, D. C. Chester Dale Collection.*
Above: Engraving from Abraham Munting's *Decorative Floral Engravings*, 1696. *Dover Collection.*

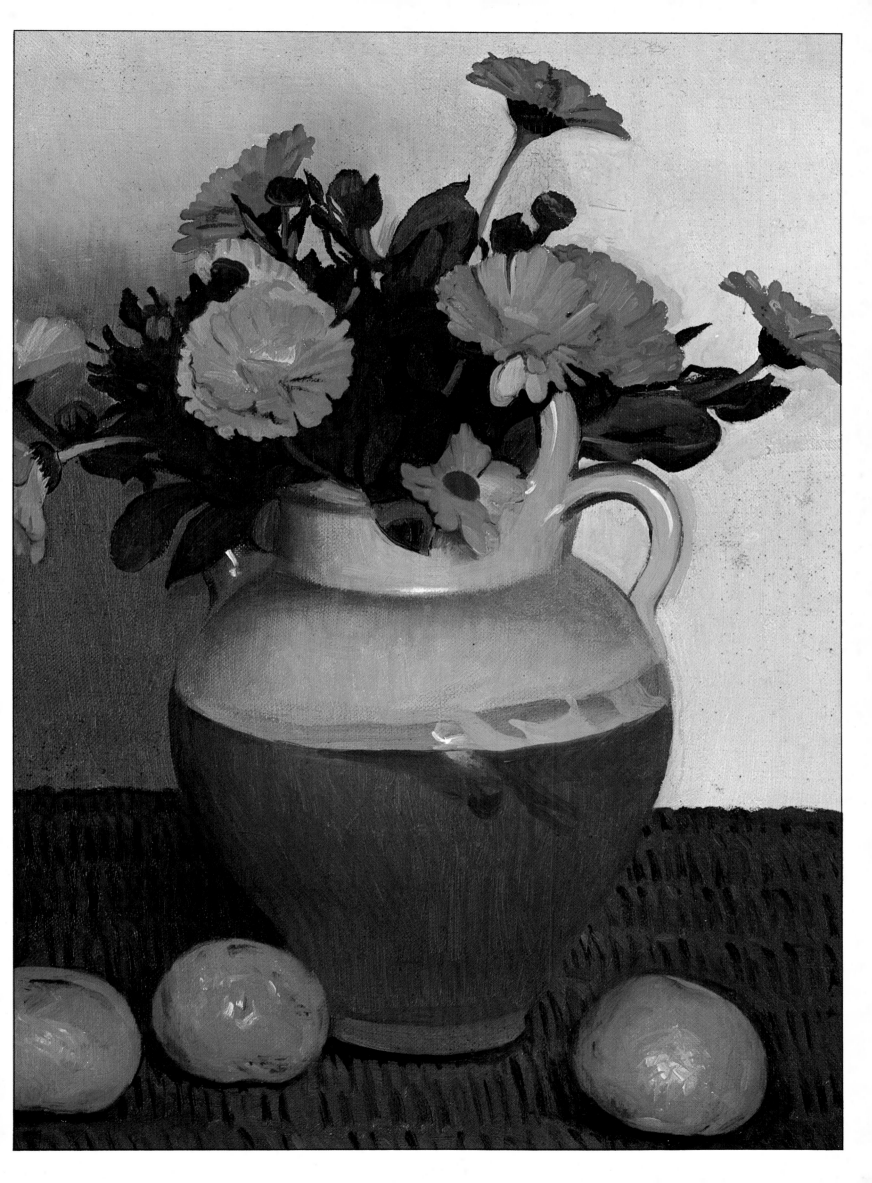

Morning Glory

The morning glory is a native of tropical America. The trumpet flower on its climbing vine opens in the morning and closes by midday. Varieties which do well in the garden are the Scarlett O'Haras, the pearly gates, and the heavenly blues. Morning glories grow almost too well. Their roots will take over the garden if not closely watched.

Around 1621, John Goodyer in England described the morning glories of his day as "Those (flowers) that will open in the morning, making some small shewe overnight."

The morning glory was compared to the life of man in the eighteenth century by the Reverend William Hanbury in *A Complete Book of Planting and Gardening*. "It has flower buds in the morning, which will be full blown by noon, and withered up before night." The flower was especially popular among seventeenth-century Dutch and Flemish flower painters. They liked the contrast of its pale blue and white flowers with the strong colors of the formal flowers.

There was once a harsh purgative medicine called scammony that came from the roots of one morning glory. The Greeks knew of this medicine and used it with caution.

In the early 1960s a rumor spread through America that chewing the seeds of the morning glory caused hallucinations. This narcotic property of the seeds was later disproved and they were declared harmless, deflating the myth.

IN THE LANGUAGE OF FLOWERS:
Departure, farewell.

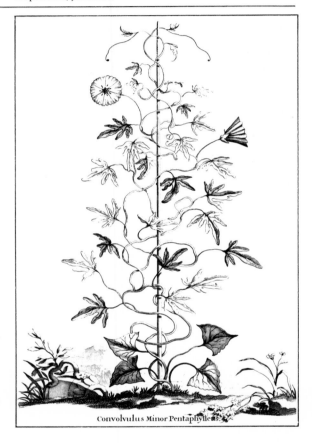

Convolvulus Minor Pentaphyllus

Opposite: Morning Glory. 20th century. Audrey Buller. American. Oil on canvas. *The Metropolitan Museum of Art.* George A. Hearn Fund, 1938. *Above, right:* Engraving from Abraham Munting's *Decorative Floral Engravings,* 1696. *Collection, Dover Publications. Above, left:* Engraving from *Maule's Seed Book,* Philadelphia, Pa., 1929.

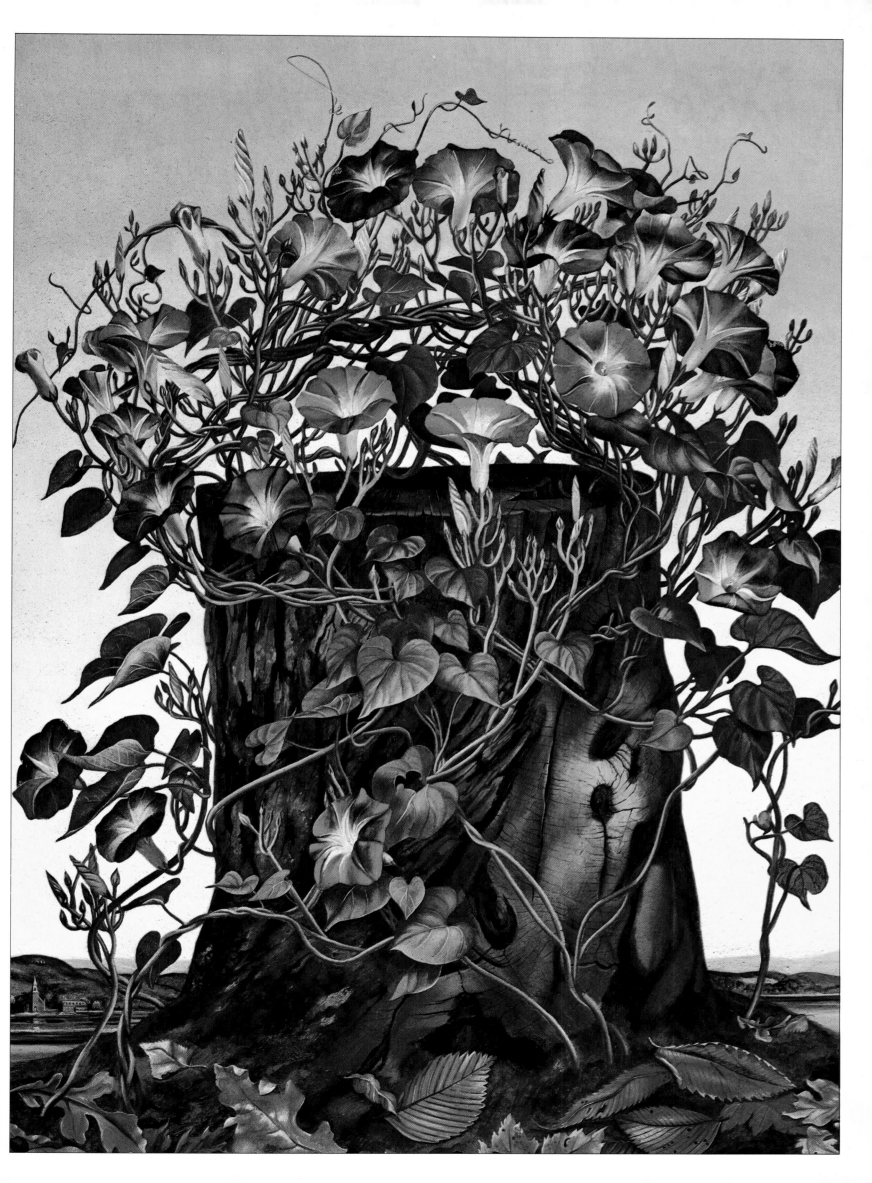

Narcissus

"The Narcissus wondrously glittering, a noble sight for all, whether immortal gods or mortal men; from whose root a hundred heads spring forth, and at the fragrant odour thereof all the proud heaven above and all the earth laughed, and the salt wave of the sea."

Homer, Hymn to Demeter.

The narcissus family owns many hearts the world wide. One of the easiest and most widely grown of all bulbs, narcissus includes daffodils and jonquils. In the spring, the white and yellow heads of these flowers sway in the meadows, enchanting the air with their sweet breath.

Three thousand years ago, the Egyptians grew flowers of the narcissus family for use in burial wreaths and funeral processions. Preserved remains of the flower are clearly recognizable in wreaths found in the tombs of pharaohs.

In Greek mythology, Pluto's touch turned a narcissus from white to yellow when he caught Persephone asleep with a wreath of them in her hair. Other Greek myths recount how the Furies wore narcissus in their tangled hair and used the flowers' strong scent to stupefy their victims.

In ancient times, the scent of the narcissus was considered harmful in a closed room. It was believed to cause headache and eventual madness. This belief lasted through the nineteenth century.

In ancient China, the narcissus was cultivated in bowls of pebbles and became the emblem of spring. They called the flower the sacred lily of China.

In 1911, the daffodil was adopted as the national flower of Wales at the investiture of Edward, Prince of Wales. The history preceding this event goes back to 1485 when Henry Tudor sought to liberate his native Wales from the hands of the English. He landed secretly on the shores of South Wales and went about gathering forces for his cause. He used the colors of green and white as a recognition signal among his followers. If one of his followers carried either a leek or a daffodil (both are green and white), he took this as a sign of allegiance to his cause. For centuries afterward, there was rivalry between the common leek and the aristocratic daffodil for the position of national flower. Not until the twentieth century did Wales make its choice.

Homer wasn't the only poet charmed by the narcissus. Almost two thousand years later, Wordsworth was to write his famous poem, *Daffodils*:

For oft, when on my couch I lie
In vacant or in pensive mood,
They flash upon that inward eye
Which is the bliss of solitude;
And then my heart with pleasure fills,
And dances with the daffodils.

The Roman naturalist Pliny believed the name narcissus originated from *Narce* stemming from the narcotic scent of the flower. But most of us think back to the Greek myth about the youth Narcissus. He refused all love of others when he fell in love with his own image, relfected in a pool of water. He was doomed to this lonely self-love until Nemesis changed him into a flower. When the nymphs came to bury his body, they found "rising stalks with yellow blossoms crowned."

IN THE LANGUAGE OF FLOWERS:
Egotism;
Chivalry, the great yellow daffodil;
I desire a return of affection, jonquil.

Opposite: Narcissus et Radis (Narcissus and Radishes). Mid-18th century. Roland de la Porte. French. Oil on canvas. Private collection. Sweden. Above, right: Harper's Bazaar poster by Louis Rheade, 1896–1898. Collection, Alan Trachtman. Above, left: Engraving from Abraham Munting's Decorative Floral Engravings, 1696. Narcissus, the youth who was turned into the flower, enamoured of his own reflection.

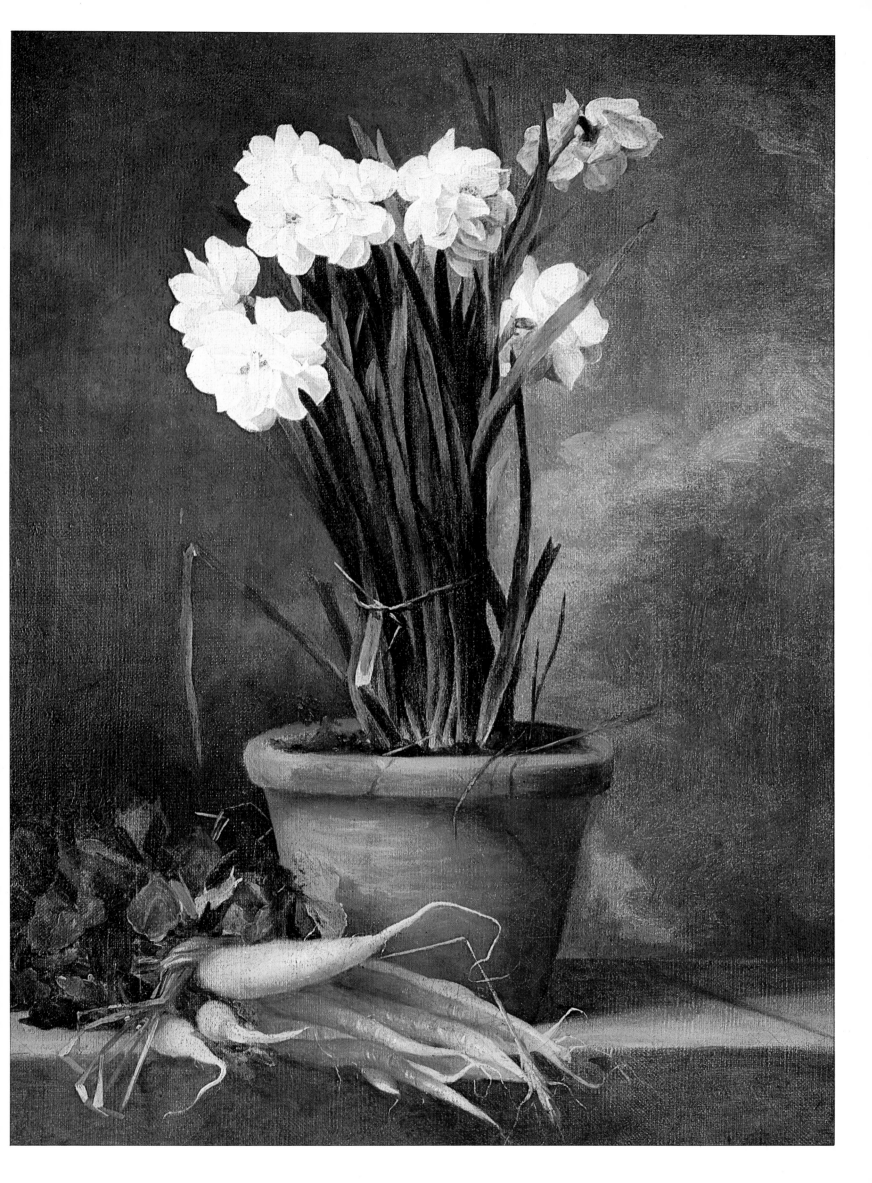

Nasturtium

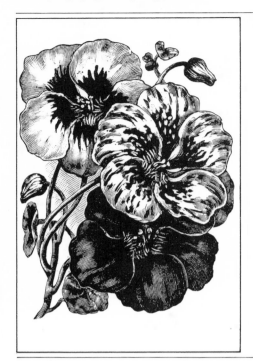

Nasturtiums are natives of Central and South America. The name nasturtium means "nose tormentor." It was given the original flower because of the biting, peppery taste of its leaves.

The seeds of the nasturtium arrived in Europe from the "Indies" around 1597. The flower became known as Indian cress because its taste so resembled their familiar watercress.

The nasturtium is one of the most nutritious plants. Its tart leaves contain ten times as much vitamin C as lettuce. The leaves and the flowers can be tossed together for a delicious salad. An elegant soup can be made from the flowers and leaves also, not to mention the sandwich filling of the same combination. When the green seed pods are cured in vinegar and spices, they pass as a decent substitute for capers.

The Swedish botanist Linnaeus gave the nasturtium the Latin name *Tropaeolum*, from *Tropaeum*, a trophy. The round leaves of the flower reminded him of a shield, and its yellow and orange flowers of a soldier's helmet. The whole flower resembled the *tropaeum* (trophy), a pillar that was raised in the middle of a battlefield and draped with the captured armor of defeated soldiers.

In 1702, Linnaeus's daughter reported seeing sparks of light fly out of the nasturtium around sunset on summer evenings. Goethe, among others, also wrote of seeing these same electrical flashes burst from the flower. Something of a craze ensued for "nasturtium watching." Modern science has since deflated their mystery by describing the phenomenon as nothing more than an optical illusion.

The nasturtium we know today has yellow and orange flowers with a pleasing, sweet scent. There are several other varieties, in shades of cream, pink, and deep red, all of which have little or no fragrance at all.

IN THE LANGUAGE OF FLOWERS:
Victory in battle.

Opposite: Mandeville and King Superior Flower Seeds. 1890s. Louis Rheade. American. Poster. *Collection, Alan Trachtman. Above:* Engraving from *Maule's Seed Book,* Wm. Henry Maule, Philadelphia, Pa., 1929. *Below:* Engraving from 1888 *Farm Annual,* W. A. Burpee, Philadelphia, Pa.

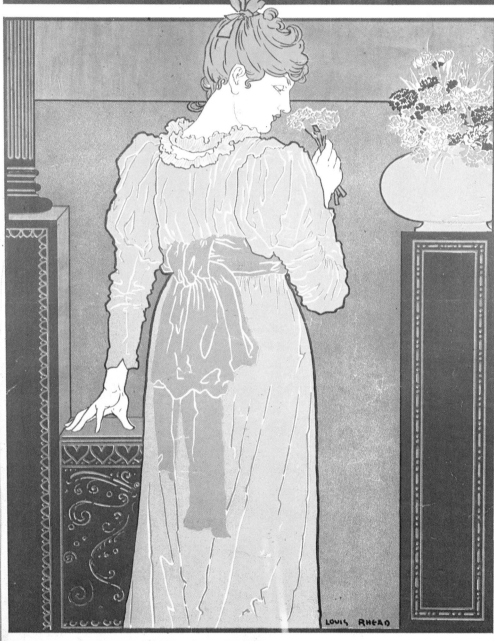

MANDEVILLE AND KING

LOUIS RHEAD

SUPERIOR
FLOWER·SEEDS
·ROCHESTER·N·Y·

Orchid

The aristocratic orchid is a member of the second largest family in the vegetable kingdom. Orchids grow in such diverse locations as the Arctic and the desert, high in the mountains, and at sea level. The most fragrant and colorful orchids prefer the humid climate of the tropics.

Contrary to legend, orchids do not capture either insects or people. Nor do they have any outstanding medicinal properties. Nor are they potent as an aphrodisiac.

The orchid, *V. fragrans* (vanilla planifolia), was at one time the world's only source of vanilla. This flavoring comes from the fruit of the orchid's seed pods, familiar to us as the vanilla bean. While the Aztecs had used vanilla for centuries, it wasn't until the invasion by Cortes in 1520 that Europeans learned about the spice. A conquistador observed the emperor of Montezuma drinking chocolate flavored with the vanilla bean. The Spanish, delighted with the new taste, took some plants of *V. fragrans* back to Europe with them.

People tried to grow this orchid in many different locations. However, they all failed because only certain Mexican bees and hummingbirds could fertilize the plant. So for over three centuries, Mexico was the sole supplier of vanilla to the world. Technology being what it is, a synthetic vanilla is now produced at about half the cost of extracting the vanilla bean from the orchid.

During the nineteenth century, the orchid was so popular in Europe that it brought prices higher than those for tulip bulbs during the "Tulipomania" craze. Plant hunters were sent off to search the world for rare species of orchids. It was often a dangerous and arduous and unsuccessful venture. They explored the hills of China, the jungles of Africa, and the swamps of South America. If they retrieved a rare orchid, the prize was well worth their effort. The plant hunters were after treasure more valuable than gold or jewels to those transfixed by the beauty of the orchid.

Today we admire the flower, but do not feel the same compulsion to possess its soul.

The forests of southeast Asia are the home of some of the best known orchids. These include the Coelogynes, the Dendrobiums, and the fragrant Vandas, the most famous of which is the blue orchid.

IN THE LANGUAGE OF FLOWERS:
Magnificence.

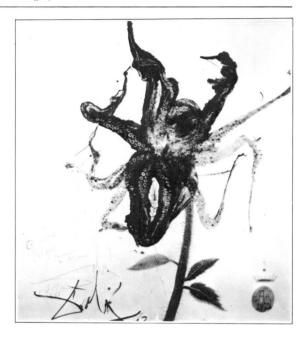

Opposite: Orchids, Passion Flowers and Hummingbird. Detail. ca. 1865. Martin Johnson Heade. American. Oil on canvas. Collection of the Whitney Museum of American Art. Gift of Mrs. Robert C. Graham in honor of John I. H. Baur. Above: Black Orchid. 1964. Salvador Dali. Spanish. Collection, Carlos B. Alemany, New York.

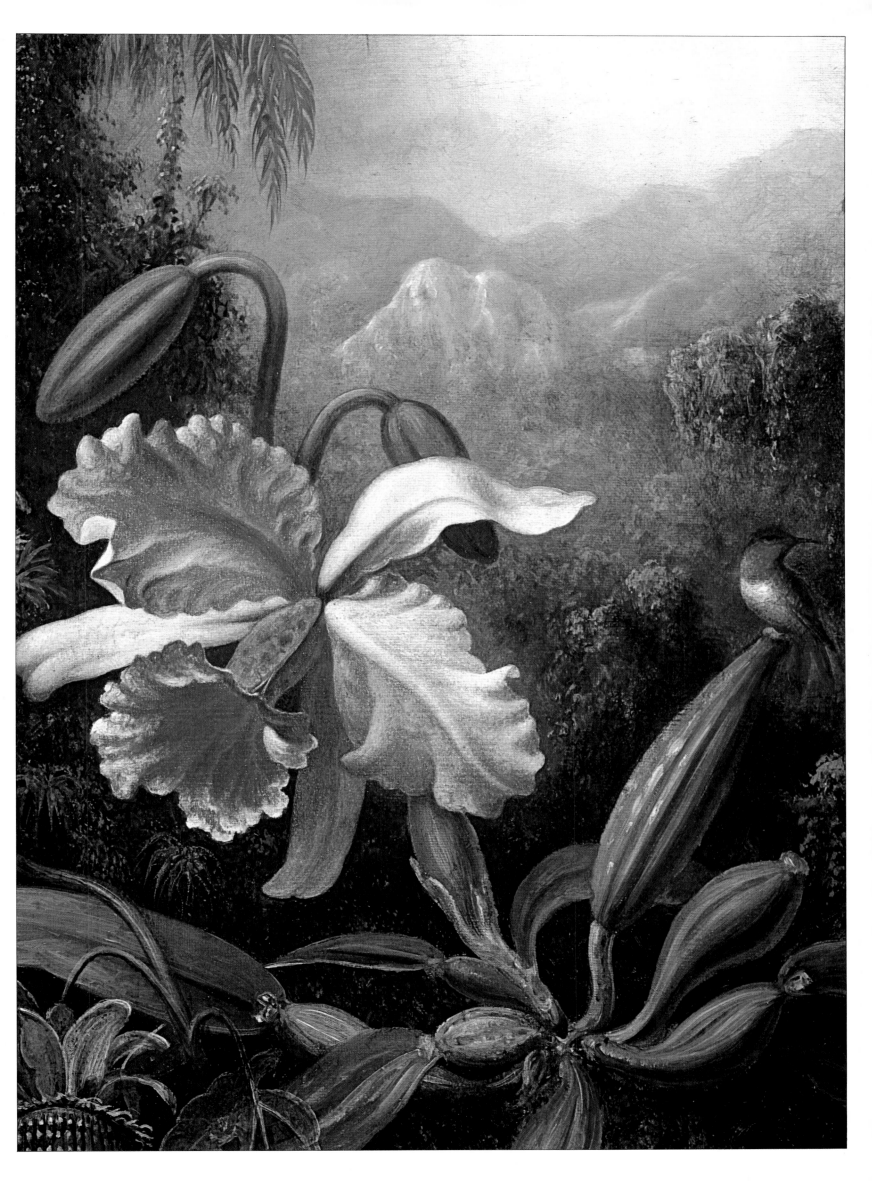

Pansy

Pansies are the friendly clowns of the garden world. Ruffling slightly in the breeze, these little flowers lift their faces to the sun and almost seem to smile. Their color combinations are endless. Soft and velvety to the touch, the pansy has charmed gardeners from one side of the world to the other.

The pansy as we now know it did not exist until the mid-nineteenth century. The present flower is derived from the genus *Viola* and has been cultivated to improve both its beauty and its constitution.

The wild pansy known to the Elizabethans was called heart's ease. The stems of the plant were weak, the flowers fragile and pale. But to Europeans, this pansy seems to have had the same charm as its modern relative. It received over two hundred affectionate names in Europe and some sixty alone in English.

This was the pansy the English poet Spenser referred to as "pretie Pawnce." Shakespeare's sad Ophelia ended one of her speeches with "Pansies, that's for thoughts." The name pansy is believed to derive from the French *pensée,* thought. However, the famous lexicographer, Dr. Johnson, defined pansy as derived from the word panacea, probably because the pansy was supposed to be a cure for French Pox, an old name for venereal disease.

Queen Elizabeth had pansies in her garden. The Empress Josephine, Napoleon's wife, also cultivated the little flowers in her famous gardens at Malmaison. Yet, it wasn't until the middle 1800s that the lavish flowers we know today burst on the scene.

The pansy was the ideal flower to the Victorians. These were the years when the flower was bred to produce the most exquisite markings and the most symmetrical forms. Floral societies held shows all over Europe just to display the extravaganza of pansy "faces."

As might be expected, these pansies grown for exhibitions were fine in the hothouse, but didn't do well in the garden. Nowadays we have accepted the smaller "faces" and less flamboyant colors of the hardier breeds. Certainly none of the flower's charm has been sacrificed, and they still seem to lift their faces to the sun and smile.

IN THE LANGUAGE OF FLOWERS:
Thoughts.

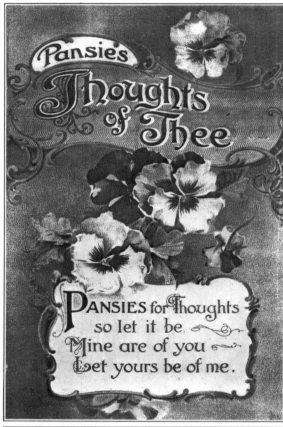

Opposite: Still Life With Pansies. Detail. 1874. Henri Fantin-Latour. French. Oil on canvas. *The Metropolitan Museum of Art.* The Mr. and Mrs. Henry Ittleson Purchase Fund, 1966. *Above:* Postcard from 1912, front and back.

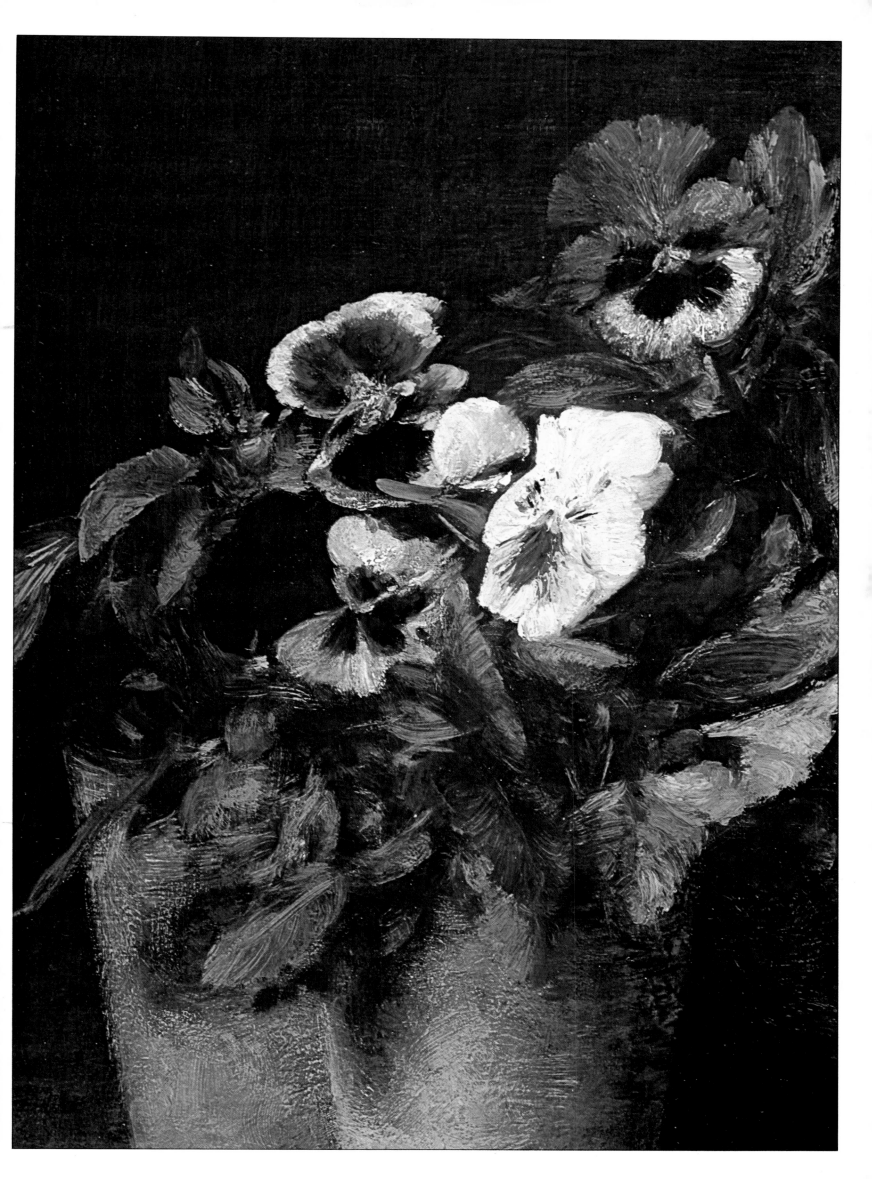

Peony

In ancient times, the peony's roots were thought to possess magical powers. In the third century B.C., the Greek philosopher Theophrastus described the difficult and dangerous task of procuring the flower's roots in his *Enquiry into Plants*. They must be dug in the dead of night. The night should be moonless, for if a woodpecker chanced upon the scene, there is risk of attack with a possible loss of eyesight. A hungry dog should be present, tied to a tree, and teased with roasted meat. The dog's famished howl would mask the groans of the plant as its roots are being torn out. (The peony's groans were, evidently, fatal to anyone who heard them.)

After the roots were safely in possession, a small piece should be cut and worn as an amulet around the neck. This was believed a protection against evil spirits. Children could wear necklaces of the roots, strung like beads on leather, to cure teething and to ward off convulsions. The roots were also considered a cure for wounds.

The roots of the peony *lactiflora*, a native of Siberia, Mongolia, and northern China, were boiled for soup by the Daurians and the Mongols. The seeds were ground into a tea. This plant, also known as the Chinese peony, is still used in some parts of China as a medicine.

It was in the Orient that the peony's beauty received such eloquent praise. Not only were there garden varieties, but there also grew in China a variety known as the tree peony. More shrub than tree, these flowers date back to the sixth century. One of the Chinese names for this flower was "Most Beautiful." There are stories that these plants grew to be over two hundred years old.

During the Tang dynasty (A.D. 618–907), peonies were placed under the protection of the emperors. They were so esteemed that they were exchanged as dowries. In ceramics, textiles, and other pictorial renderings, the peony, called the "king of flowers," was often shown with the phoenix, the "king of birds."

The peony was introduced to England around 1548, during the Tudor years. The tree peony didn't come out of China until much later. This particular variety of peony was too revered to be traded lightly with outsiders.

Lightly scented, the peony comes in shades of pink, red, and white, and grows with very little effort on the part of the gardener.

The peony is named after Paeon, the divine physician who used the flower's roots to cure a wound given to Pluto by Hercules.

IN THE LANGUAGE OF FLOWERS: *Bashfulness.*

Opposite: Tige et Fleurs de Pivoines (Twig and Flowers of Peonies) ca. 1864. Edouard Manet. French. Oil on canvas. *Louvre*, Paris. *Above:* Japanese ceremonial robe of gold, pink and white tree peonies. *Collection, National Museum of Tokyo.*

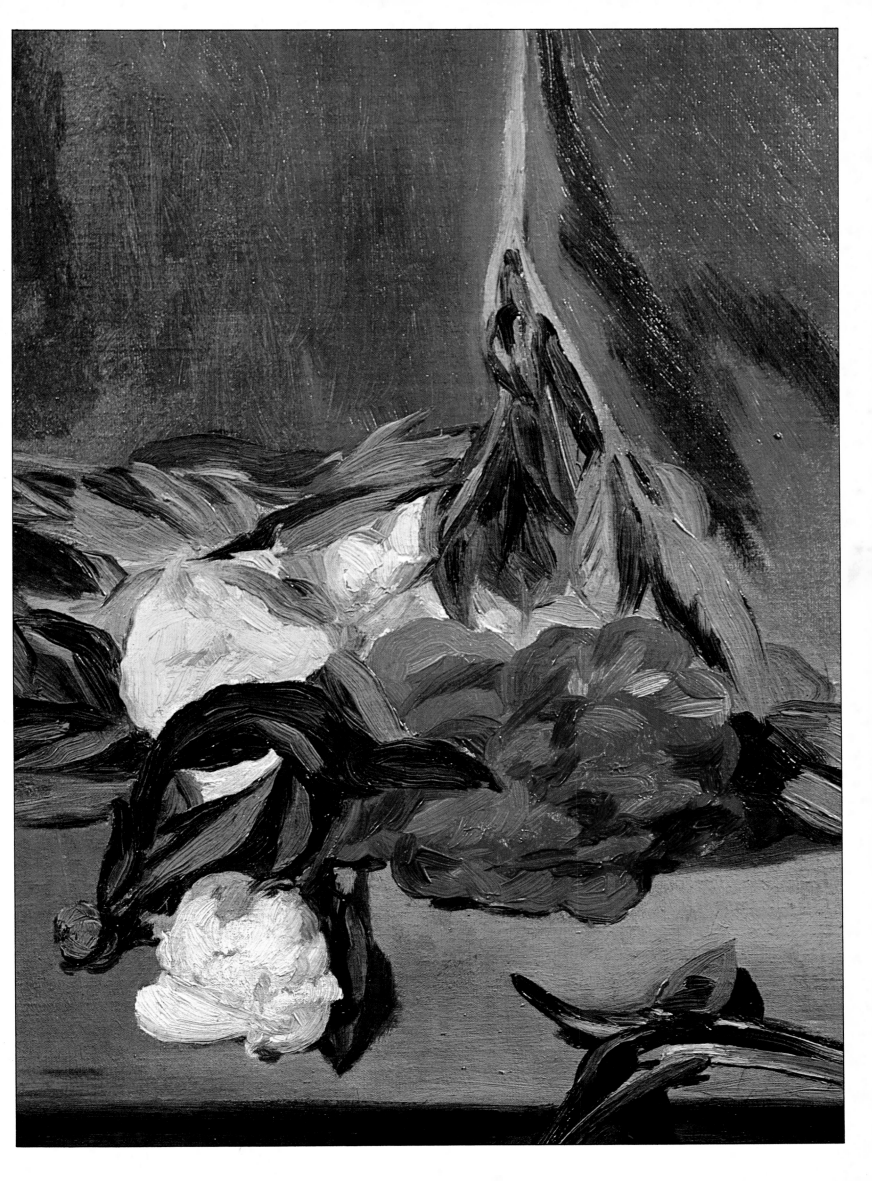

Poppy

"...Not poppy nor mandragora
Nor all the drowsy syrups of the world,
Shall ever medicine thee to that sweet sleep
Which thou ow'dst yesterday..."
 Iago in Othello, *Act III, Sc. 3*

The sight of a field crowded with floppy red, white, or purple poppies is a lighthearted, almost comical, experience. There is no hint in their gay, dancing forms that one of them, the opium poppy (Papaver somniferum), has a darker, more serious side. The flower of silence and sleep, as it is often called, its sap contains a narcotic that is at once powerful and dangerous.

According to classical mythology, Somnus, god of sleep, created the poppy to help Ceres achieve rest from her cares. Worried and exhausted from sleeplessness, Ceres was neglecting the crops. After she'd slept, the crops revived. Forever after, Ceres has been depicted wearing a garland of poppies and cornflowers entwined in her hair.

The Egyptians and the Greeks knew about the powers of the opium poppy to induce sleep. There are renderings of the white and purple poppy on the walls of Egyptian temples. Descriptions of its medicinal properties are found in writings of the Greeks.

Opium is extracted from the maturing seed pods of the poppy. Around sunset, a slice is made in a seed pod. This yields a sap that when left overnight coagulates. The next day, drops of the crystallized sap are scraped off, dried, then kneaded into brownish balls. This crude form can be smoked as a narcotic. When chemically processed, it yields heroin.

A more purified form of opium is also an important ingredient in morphine, codeine, narcotine, and other alkaloids. Opium has had its dark side. But it has also been of great benefit to medicine through its ability to ease pain and suffering.

Other parts of the opium poppy, especially its seeds, contain no traces of the narcotic and are delicious to eat. Olympic athletes of old mixed the seeds with honey and wine when they trained, believing it gave them strength and endurance. Many specialty food stores today carry bread glazed with egg yolk and sprinkled with poppy seeds.

With all the attention paid to the opium poppy, the field poppy has been all but forgotten. This charming flower probably originated in the Middle East. It yields nothing more potent than a red pigment used in dye for coloring wines and medicines. Its flowers are red and white. They were often used by the Dutch in their floral painting of the seventeenth century.

There is a touching legend about the Battle of Waterloo concering the field poppy. In the spring that followed Napoleon's defeat by Wellington, the fields at Waterloo were blanketed with red poppies. It was believed that these flowers sprang from the blood of the soldiers killed in battle.

A hundred or so years later, another battlefield was discovered thick with the same blood-red poppies. This time it was World War I, and the battlefield was at Flanders.

IN THE LANGUAGE OF FLOWERS:
Dreaminess;
Silence, the oriental poppy;
Consolation, the red poppy.

Opposite: From Poppy With Love,
poster. 1967. Milton Glaser.
Above: Pen and ink by
Fred Ball, 1899, for *The Studio. Collection, Dover Publications.*

FROM POPPY WITH LOVE

Rose

The rose is the most celebrated flower in the Northern Hemisphere. It is also the oldest domesticated flower on record. Fossil remains of the rose can be found in museums all over the world. The Oligocene deposits in Colorado contained fossilized roses said to be at least thirty-five million years old.

The history of the rose reads like a history of the world. Ancient drawings of the rose from the sixteenth century B.C. were discovered on the cave walls of Knossos, Crete. The Island of Rhodes was named after the flower. Coins inscribed with roses date back to 4000 B.C. King Sargon of Babylon (c. 2637–2582 B.C.) sent rose trees to his capital at Akkad. Assyrian architecture contains many carvings of the rose.

In the Iliad, Aphrodite was said to have anointed the dead Hector with rose perfume. Roses marked all kinds of ceremonial occasions in the ancient capitals of Greece and Rome. In Rome, flowers were woven into garlands and draped over tombs as a sign of returning spring and the renewal of life. Brides and grooms wore chaplets of roses. Athletes were crowned with roses. Rose petals were tossed in processions and lavishly strewn about banquet halls.

On one such occasion, there were so many rose petals let loose from the ceiling during a banquet given by Emperor Elagabalus (c. A.D. 204–222) that some of the guests were actually suffocated.

The Romans also regarded the rose as the flower of silence. Cupid was said to have bribed Harpocrates, the god of silence, with a rose (the emblem of love) to keep him from revealing love affairs carried on by Venus. The Roman hung a rose from the ceiling of council chambers to indicate the need for secrecy when confidential matters were discussed. Everything said at these meetings was then "sub rosa," and not to be repeated.

The early popes refused to allow the rose in churches because of its association with the debauchery of the Roman Empire. But the church later changed its mind and the rose became the symbol of martyrdom, the five petals representing the five wounds of Christ. The white rose became the symbol of Mary's virginity.

St. Dominick was supposed to have received a chaplet of roses from the Virgin Mary, and it was this chaplet that the rosary came to symbolize. The first rosaries were strings of beads made from rose petals tightly pressed together into tiny fragrant balls.

The association of the rose with England dates back to the fifteenth century and the thirty year struggle for the crown, known as the War of the Roses. Leaders of the two contending houses chose roses to identify their supporters. The Yorkists chose a white rose, the Lancastrians, a red rose. Victory to the House of Lancaster raised Henry VII to the throne. He married Elizabeth of York and chose a third rose to signify the peaceful union between the two houses. A canny monarch, he selected a new rose which produced a variety of flowers, some solid pink, some solid white, some mixed in color. It became known as the York and Lancaster Rose.

The rise of the Tudor House begat the Tudor Rose. This was the red rose that finally achieved its position as the national flower of England.

In the language of flowers, to give a rose is to say "I love you." The unopened rose signifies unawakened love. The rose in full bloom has come to mean beauty at its fullest—but beauty that must pass. The red rose is the flower of passion and ardour. The white rose is the flower of purity and spiritual love.

The oil of the rose is one of the most valuable in the world. Attar of rose is the base of almost all perfumes.

There are many varieties of the rose, and these flowers grow all over the world. Some are as large as plates, some are tiny enough to slip through a wedding ring. Some climb, some creep, some grow as shrubs, some as bushes. The flowers can be double or single and come in shades of white, red, pink, orange, yellow, lavender, and even green. No one has yet produced a blue rose, but who knows what the future might bring?

IN THE LANGUAGE OF FLOWERS:
Love, the red rose;
I am worthy of you, the white rose;
Unity, the red and white rose together;
Jealousy, the yellow rose;
Grace, the pink rose.

Opposite: Le Billet Doux. Detail. Late 18th century. Jean Honoré Fragonard. French. Oil on canvas. *The Metropolitan Museum of Art.* The Jules S. Bache Collection. *Above:* Poster for *The Century Magazine* by Louis Rheade, late eighteen hundreds. *Collection, Alan Trachtman.*

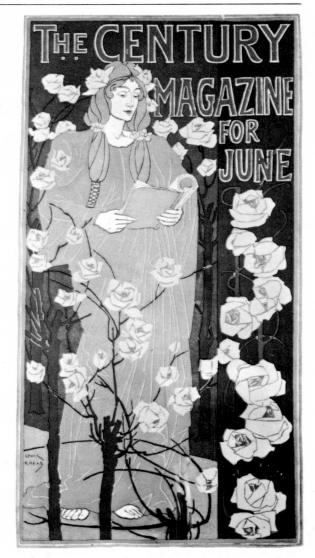

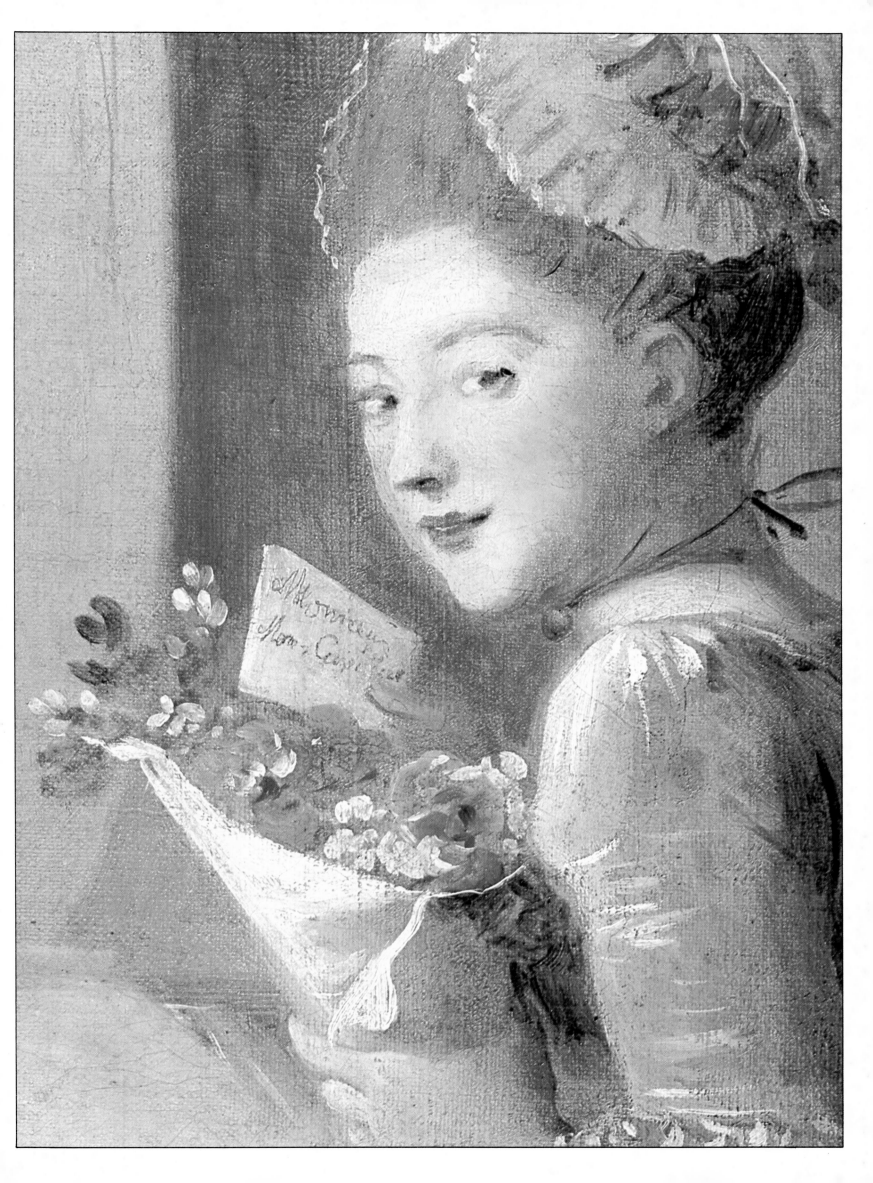

Rose

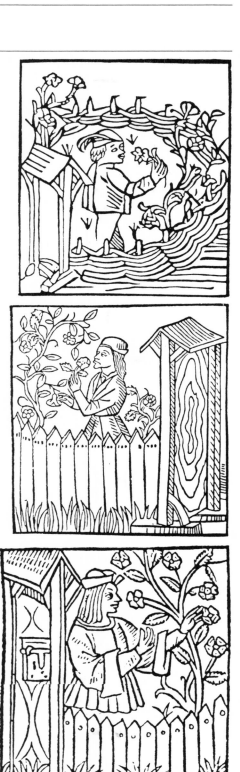

Opposite: Nightingale and Rose Tree.
Quajar Period, late 18th or early
19th century. Artist unknown. Per-
sian. Gouache on paper. The Free
Library of Philadelphia. John Fred-
erick Lewis Collection. Above:
Woodcuts from The Romance of the
Rose, 1481; from The Romance of the
Rose, 1538; from The Romance of the
Rose, fifteenth century.

56

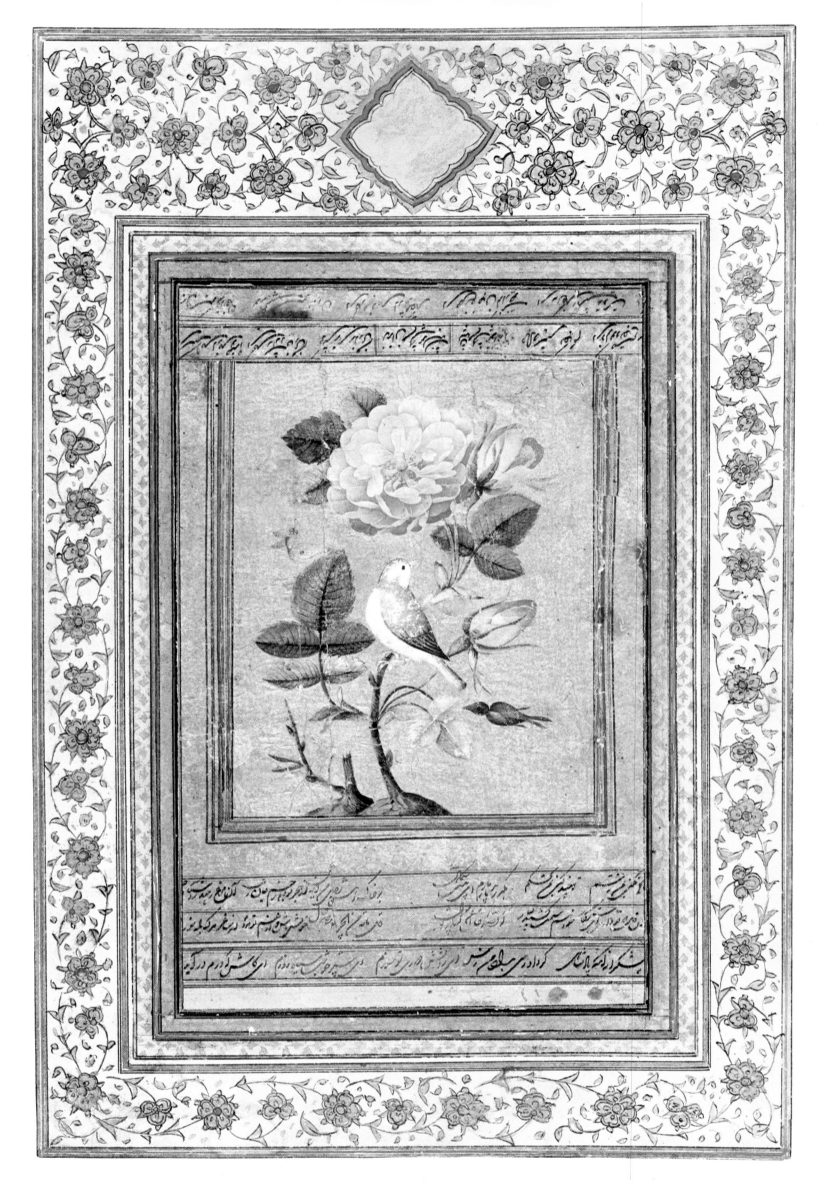

Rose

Opposite: Les Fleurs Animées (The Rose). 1847. J. J. Grandville. French. Colored Engraving. *Above:* Victorian decoupage, postcard and decoupage. German and English.

Sunflower

A native of western North America, the sunflower now has admirers all over the world. This glorious yellow flower is called *helianthus*, from the Greek words *helios* (sun) and *anthos* (flower) because of the way it turns its face to follow the sun.

Ever since *Helianthus* was discovered, there have been rivalries and disputes among those claiming to have produced the tallest flower. An average sunflower might grow as tall as fourteen feet, but specimens of seventeen feet or more have been recorded.

Centuries ago, the sunflower spread from North America to Peru. The Incas adopted the flower as the emblem of their sun god. Carved on their temples and worked in their gold jewelry by the priests, the sunflower was cultivated and given reverential attention.

In the book *Flora of the Americas*, published in the sixteenth century, the author Dr. Nicholas Monardes described having seen the sunflower around 1569 growing in the Americas. The seeds from the flower were among the first brought back to Europe from the New World.

In 1847, Mormons used the seeds of sunflowers to mark their trail across the west. Setting out from Missouri in search of a place to worship God, they scattered sunflower seeds behind them when they crossed the plains to Utah. The women and children who would be traveling by wagon in the coming summer would then be able to follow the sunflower trails left by their men who had preceded them.

Late in the nineteenth century, Oscar Wilde brought the sunflower to the attention of the arts when he made the flower the symbol for the new aestheticism. It was around this time also that Van Gogh created his thirteen famous paintings of sunflowers.

There is hardly a part of the sunflower that isn't useful. The seeds, which are high in protein and calcium, are a delicious food. A bushel of seeds will yield close to a gallon of oil, while the leftover oil cake is a nutritious fodder for cows. A lovely yellow dye can be made from the ray flowers. The pith of the stem is used in a preparation for microscope slides. And even the stalk can be processed, to produce a fine silky fibre, excellent for writing paper.

IN THE LANGUAGE OF FLOWERS:
Adoration, the dwarf sunflower;
Haughtiness, the tall sunflower.

Opposite: Sunflowers. 1881. Claude Monet. French. Oil on canvas. *The Metropolitan Museum of Art.* Bequest of Mrs. H. O. Havemeyer, 1929. *The H. O. Havemeyer Collection. Above, right:* Caricature of Oscar Wilde by Linley Sambourne in 1881 edition of *Punch. Above, left: Sun Worshipper.* J. J. Grandville. French. Late 19th century engraving.

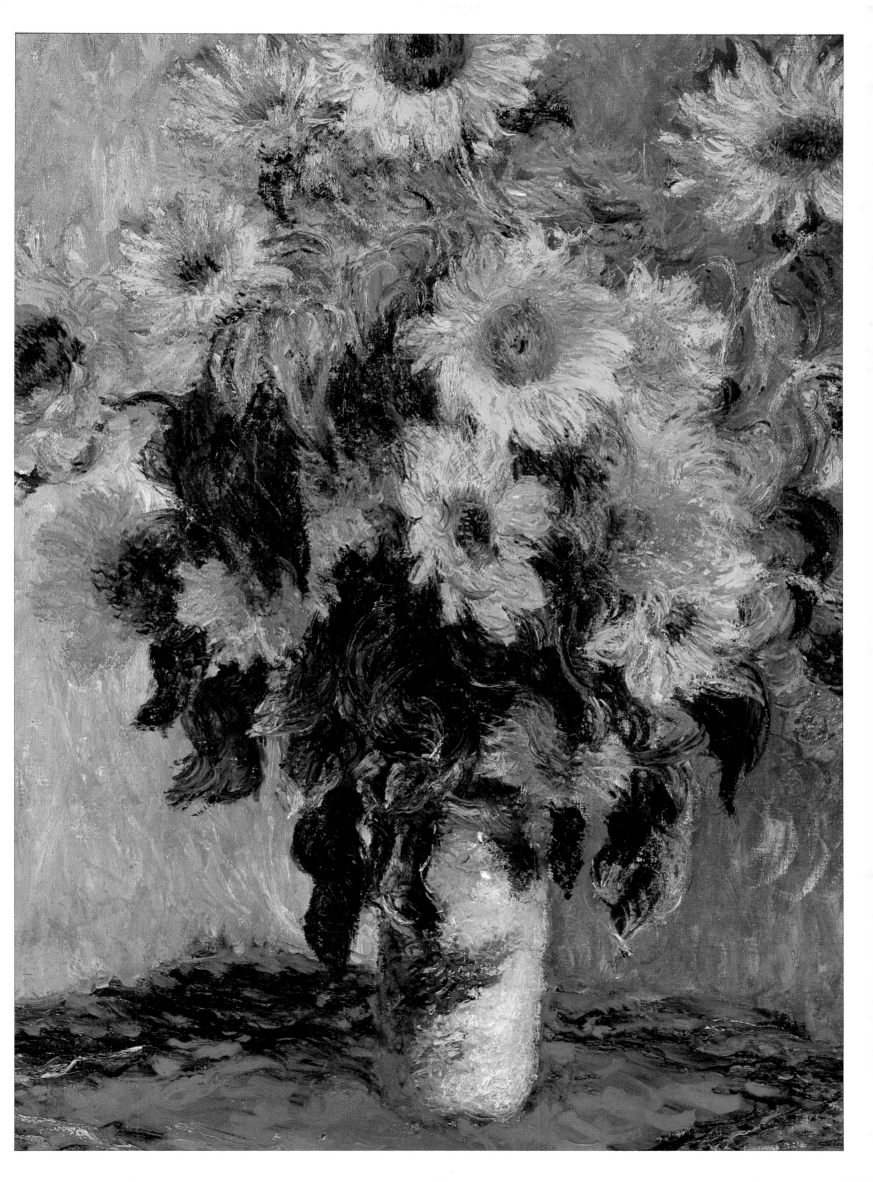

Sunflower

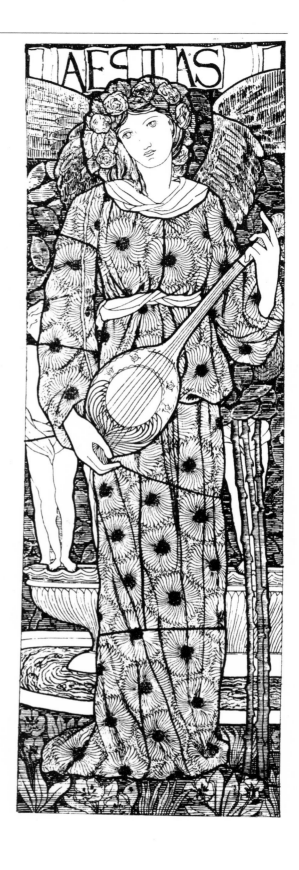

AESTAS

Opposite: Sunflowers. Detail. 1887.
Vincent van Gogh. Dutch. Oil on
Canvas. *The Metropolitan Museum
of Art.* The Rogers Fund, 1949.
Right: Drawing for a panel of
stained glass for the Prince of
Wales Pavillion in 1878. Made by J.
Powell and Sons, Whitefriars.

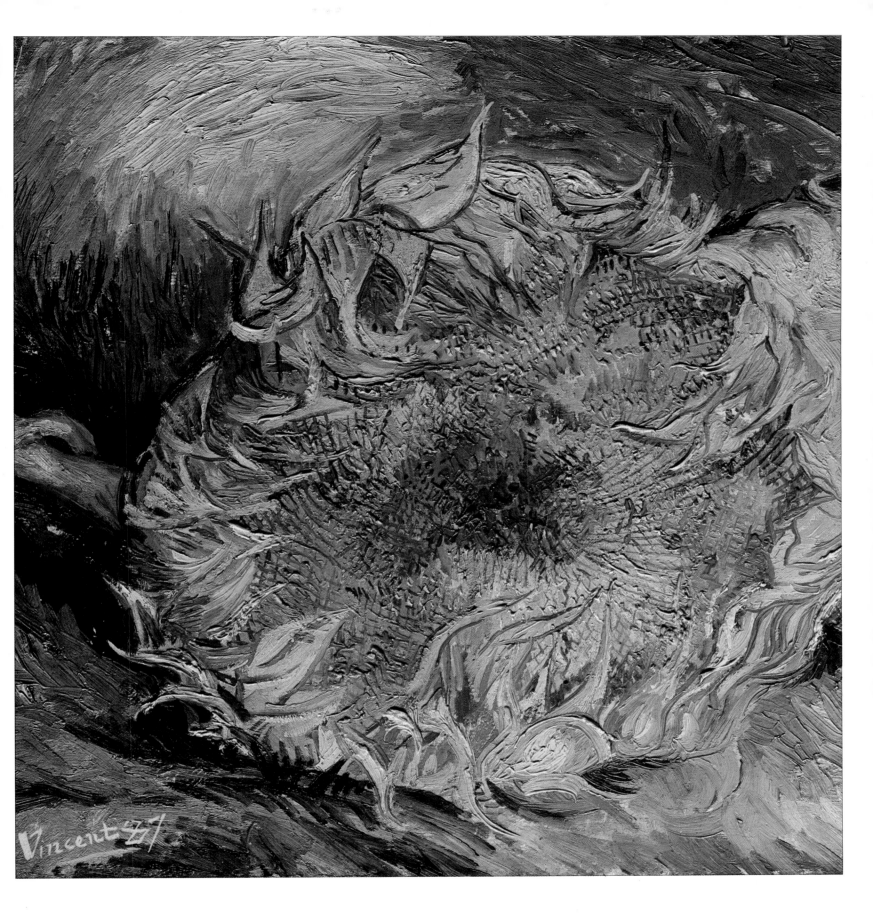

Tulip

Prized for its regal beauty, the magnificent tulip is cultivated all over the world. This graceful, long-stemmed flower blooms in the early spring through May. Some of the most familiar varieties include Rembrandt, Mendel, Triumph, Cottage, Parrot, and Darwin.

The tulip's colorful flowers seem at times to be the work of an artist. Smooth, curled or ruffled, the flowers are solid color, striped, or mottled, in shades of red, pink, crimson, yellow, orange, tangerine, cream, white, purple, mauve, and blue. There are also the plain full-colored doubles, whose rich shades glow like jewels in the sunlight.

The tulip was originally a wild flower from the Levant. It was probably first brought to Europe by the Crusaders. Strangely, there is no mention of the flower in classical literature. The earliest record we have are drawings of the tulip on a twelfth-century Italian manuscript of the Bible.

Around 1554, the ambassador to Turkey from the court of Emperor Ferdinand I of Austria was presented with some tulip bulbs as a gift from the Turks when he re-turned to Vienna. The flower earned many admirers. Twenty years later, Clusius, a French professor of botany, was sent to the Netherlands from Vienna. He took some tulip bulbs with him, only to have them stolen almost immediately upon his arrival. Evidently, he was demanding too high a price for his precious bulbs. The Dutch who were intent on cultivating the lovely flower were left to steal what they could not afford to buy.

The tulip spread quickly across Holland. At first, only the rich landowners could afford to trade the bulbs. A struggle then ensued with the Germans to obtain the latest varieties from Turkey and the Levant.

By the 1630s, seamen, landowners, farmers, and merchants began to speculate in tulip bulbs. The entire nation was gripped by "tulipomania." Fights broke out, people were killed, fortunes won and lost. There was manic speculation. Finally the government had to step in with some limits on the frenzied gambling that was taking place. When the bottom fell out of the market in 1637, hundreds of people were ruined. It was only then that this craze began to subside. There were slight revivals in later years, but nothing ever again reached the crazy pitch of trading of the 1630s.

Today the tulip industry in Holland is still an important one. Catalogs filled with hundreds of varieties go out to countries all over the world. Orders for tulip bulbs pour into Holland all year long.

The name *tulipa* comes from the Persian *toliban,* and the Turkish *dulban,* or turban. There is a Persian legend that the flower sprang from the blood of Farhad, who had thrown himself off the rocks when he heard a false rumor that his beloved Shirin had been killed. In Persia, the tulip was the emblem of perfect love.

IN THE LANGUAGE OF FLOWERS:
Declaration of love, the red tulip;
Beautiful Eyes, the variegated tulip;
Hopeless love, the yellow tulip.

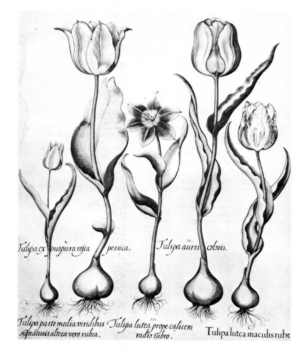

Opposite: Study of Tulips. 17th century. Jacob Marrel. Dutch. Watercolor on vellum. *The Metropolitan Museum of Art.* The Rogers Fund, 1968. *Above:* Illustration done by Basilius Besler, 1613, of one of the plants growing in the garden of the Bishop of Eichstatt.

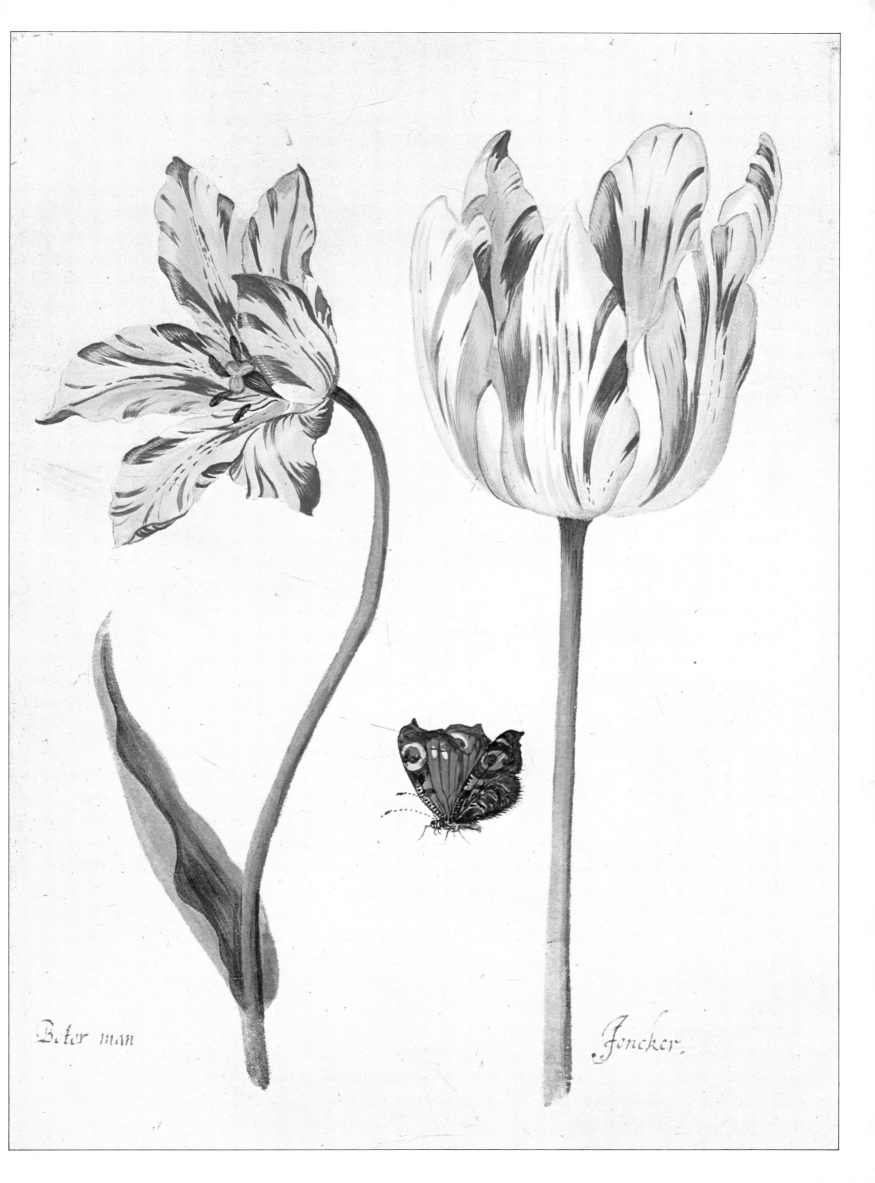

Beter man Joncker.

Violet

The tiny delicate violet is one of our most cherished flowers. There are blue violets, lavender violets, white violets, even yellow violets, each one as exquisite and fragile as the next. A bouquet of violets bears with it a message of love.

There were violets growing in the shade of the olive groves of ancient Greece. In Athens, violets were an important part of the culture. Later, they were adopted by the Romans, and served many functions as a ceremonial flower.

In the Middle Ages, violets were used for many medicinal purposes. Supposedly they relieved inflammations of the lungs and the chest. (They were also believed useful to ward off evil spirits.) A compress of violets, strawberry leaves, and poppy seeds was thought to be helpful for headaches and sleeplessness. Even today, there are some Europeans who believe that eating violet leaves will arrest the growth of cancer.

Chemists in the early nineteenth century discovered that the blue syrup extracted from the flowers had the useful property of turning red on contact with acids and green on contact with alkalis.

Napoleon was probably the most famous devotee of violets. He was said to love these flowers because they reminded him of his childhood in the Corsican woods. When Napoleon and Josephine were married, she wore violets. Every year thereafter, to mark their anniversary, Napoleon sent Josephine a bouquet of sweet violets.

When Napoleon was exiled to Elba, he promised his followers he would return with the violets in the spring. Return he did, but only to meet his most decisive defeat.

Before leaving for his final exile in St. Helena, he asked to visit Josephine's tomb. He plucked some violets near her grave. When he died in 1821, the violets were discovered in a locket around his neck.

After Napoleon's death, violets lost favor. It wasn't until the Empress Eugenie, wife of Napoleon III, began to wear them in the 1850s in memory of Napoleon that they became popular once again.

There are several legends about the origin of the violet. A Greek legend described how a weary Orpheus sat down to rest one day on a mossy bank by the river. In the place where he lay down his lute, the first violet burst forth from the earth.

IN THE LANGUAGE OF FLOWERS:
Faithfulness, the blue violet;
Modesty, the sweet violet;
Rural happiness, the yellow violet.

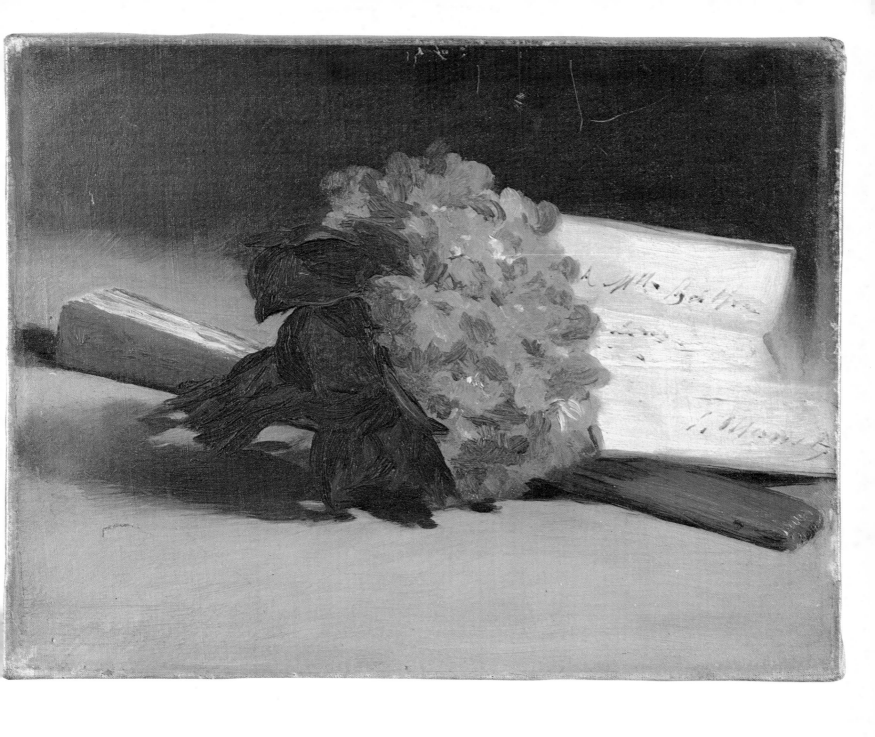

Water Lily

The water lily is known as the flower of purity and resurrection. Each season it rises undefiled from the depths of the dark, muddy waters, a living symbol of regeneration.

The ancient Egyptians idealized the water lily, known to them as the lotus of the Nile. The flowers appeared everywhere, in murals, their furniture, pottery, and jewelry. The design of the flower was even woven into their clothes.

The blooms of the lotus were cultivated for use in religious ceremonies and in the home. By custom, a slave presented his master's guests with water lilies. The guests were expected to hold the flowers or wear them in their hair, as a gesture of their peaceful intentions.

Petals of a white and a blue lotus were uncovered in the funeral wreaths of Rameses II (1292–1225 B.C.) and Amenhotep I (1557–1540 B.C.). Botanists are surprised at how similar the ancient flowers appear to our modern ones.

The name lotus is used for two kinds of plants. One is the water lily, the other the familiar lotus of the Buddhists.

The seeds of the water lily contain starch and protein, and were eaten in times of emergency by Europeans, Asians, and Africans in the past. The tubers were boiled or roasted like potatoes.

Many common symbols used in the arts can be traced directly back to the lotus, or water lily. The flower's twisted sepal has been linked to the Ionic capital, and from that to the Greek fret or meander. When this later symbol is doubled, it becomes a swastika, which, according to the way it faces, represents good or evil, male or female, light or darkness.

The water lily rests serenely on the surface of ponds, lakes, and rivers all over the world. It ranges in color from pure white to pink to rust-red to scarlet, yellow, blue, mauve, and purple. Most water lilies bloom in the morning and close at night. But in some tropical areas, the flowers rest in their closed state during the scorching hours of daylight, waiting until the cooler evening hours to open.

IN THE LANGUAGE OF FLOWERS:
Purity of heart.

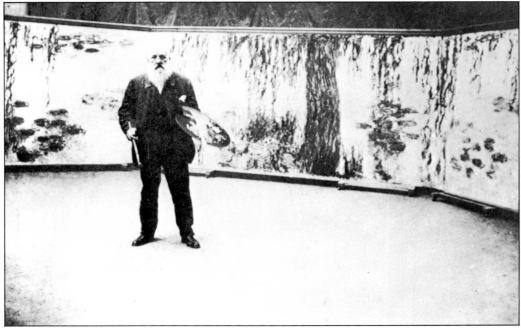

Opposite: Waterlilies (W. nymphea).
Early 20th century. Claude Monet.
French. Oil on canvas. *Louvre,*
Paris. *Above:* Engraving from
Maule's Seed Book, Wm. Henry
Maule, Philadelphia, Pa., 1929.
Below: Claude Monet in his
gigantic studio, built especially for
his series of *Waterlilies,* ca. 1900,
Collections Durand-Ruel, Piguet.

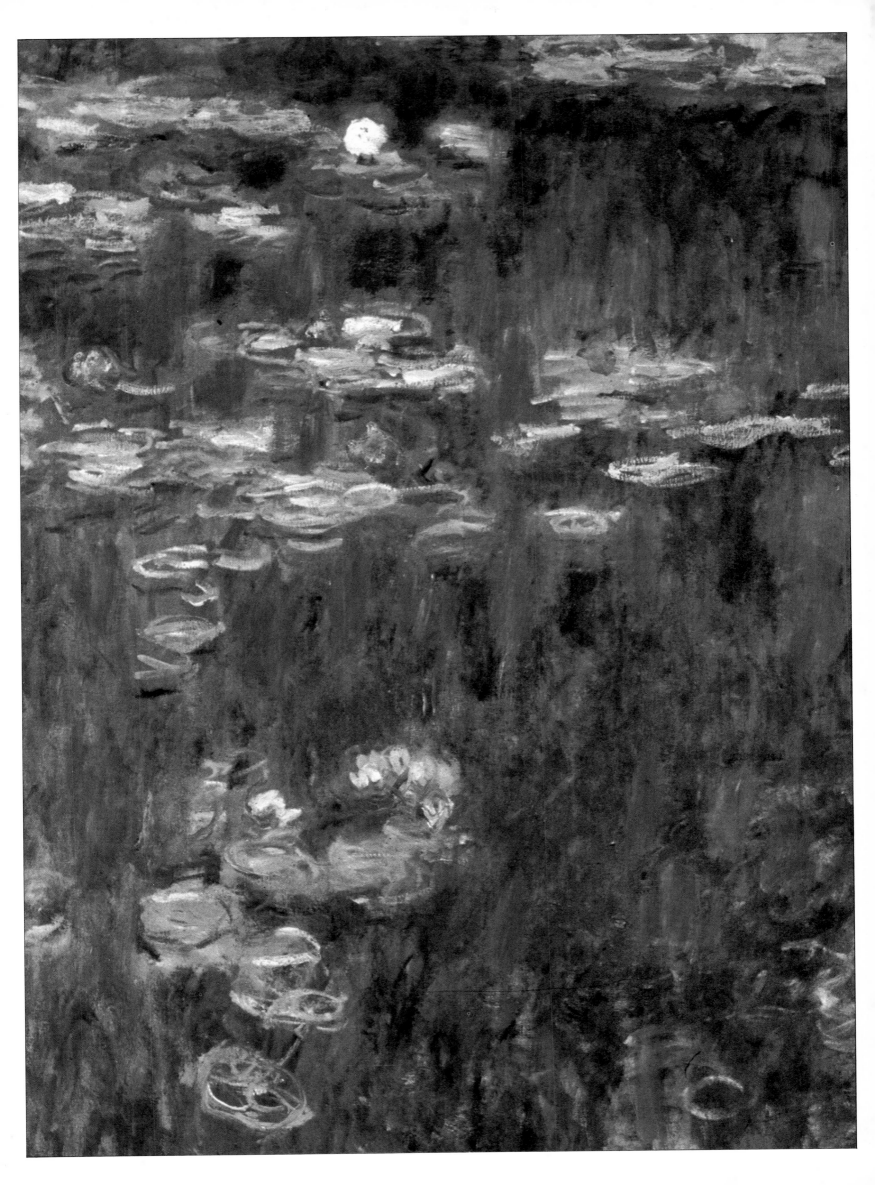

Zinnia

Zinnia is another member of the large *Compositae* family. Most varieties have double flowers with stiff stems that make excellent cut flowers. They come in shades of rose, pink, lilac, crimson, scarlet, red, orange, yellow and white. One exotic strain called Green Envy is a vivid chartreuse green.

Zinnias were originally cultivated in the splendor of the Aztec gardens. Along with the dahlia, sunflower, and morning glory, the zinnia flourished under the watchful eye of the Aztecs, whose gardening skills were highly developed.

The gardens of Montezuma were at least equal to those in Europe. It was said that Aztec gardeners used to prick their ears and scatter blood on the leaves of new plants laid in the ground. Whatever their secret, their gardens have provided the world with some spectacular flowers.

The seeds of the zinnia did not find their way to Europe until 1796, when the ancestor to our modern zinnia, *Z. elegans*, arrived in Spain.

The flower was cultivated in American Colonial gardens from 1800 on.

The zinnia was named in honor of J. G. Zinn, professor of physics and botany at Göttingen University in the eighteenth century. The flower has also been called "Youth and Age."

IN THE LANGUAGE OF FLOWERS:
Thoughts of absent friends.

Opposite: Butterfly and Zinnia. 20th century. Romano Gazzera. Italian. Lithograph. Above: Children's garden with zinnias growing in the front row. Maule's Seed Book, Wm. Henry Maule, Philadelphia, Pa., 1929. Right: Engraving from Maule's Seed Book, Wm. Henry Maule, Philadelphia, Pa., 1929.

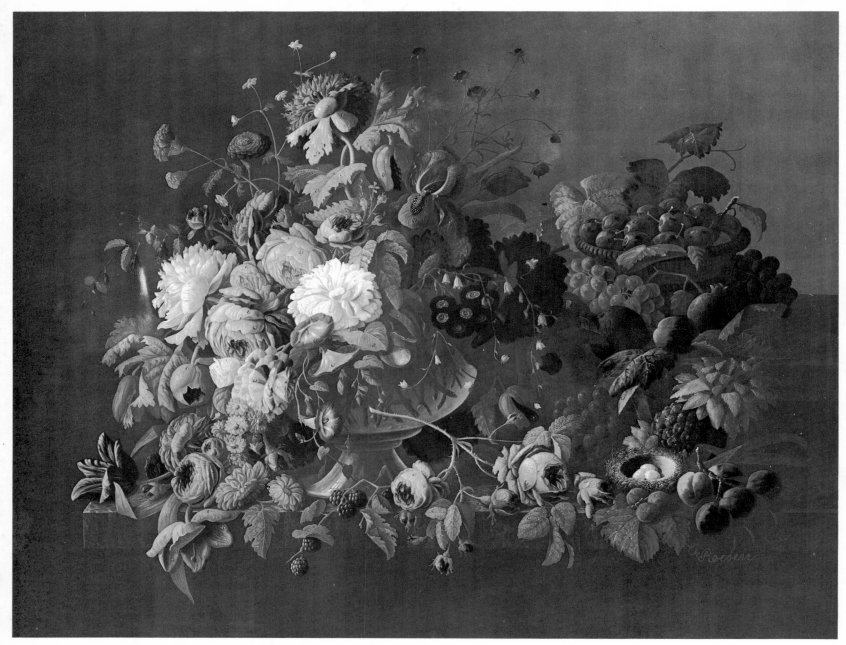